THE WINDSHIFT LINE

A FATHER AND DAUGHTER'S STORY

Rita Moir

THE WINDSHIFT LINE

GREYSTONE BOOKS

DOUGLAS & MCINTYRE PUBLISHING GROUP

VANCOUVER/TORONTO/BERKELEY

Greystone Books
A division of Douglas & McIntyre Ltd.
2323 Quebec Street, Suite 201
Vancouver, British Columbia
Canada V5T 4S7
www.greystonebooks.com

Library and Archives Canada Cataloguing in Publication
Moir, Rita, 1952–
The windshift line : a father and daughter's story / Rita Moir.

ISBN 1-55365-089-1

1. Moir, Rita, 1952– 2. Fathers and daughters. 3. Bereavement.
4. Authors, Canadian (English)—20th century—Biography. I. Title.
FC3849.W553Z49 2005 C818'.5409 C2004-906942-X

Library of Congress information is available upon request

Editing by Nancy Flight
Cover and text design by Jessica Sullivan
Cover photograph by Special photographers/Photonica
Printed and bound in Canada by Friesens
Printed on acid-free paper that is forest friendly (100% post-consumer
recycled paper) and has been processed chlorine free.
Distributed in the U.S. by Publishers Group West

An early excerpt from this text appeared in *Borealis: The Magazine of Northern
Literature, Art and Culture*, vol. 1, no. 3, St. Paul, Minnesota, Fall/Winter 2002.
An earlier version of the story "Walking with Shirley" appeared in *Going Some
Place*, edited by Lynne Van Luven (Regina: Coteau Books, 2000).
A line from *Trinity*, by Leon Uris (New York: Doubleday, 1976), appears on page 23.
Lines from "The Band Played On," by composer Charles B. Ward and lyricist
John F. Palmer, 1895, appear on page 165.

The author acknowledges the support of the Canada Council for the Arts, which
in 2003 invested $20.3 million in writing and publishing throughout Canada.

The publisher gratefully acknowledges the financial support of the Canada
Council for the Arts, the British Columbia Arts Council, and the Government of
Canada through the Book Publishing Industry Development Program (BPIDP)
for its publishing activities.

To Dad

All stories begin in the Crowsnest wind
All passages to here and there

CONTENTS

ACKNOWLEDGMENTS

\mathcal{T}his book has been under way for eight years. I hope it has matured in its aging.

My father worked long and hard to draw his stories together for me. My mother helped me as I read them to him. She has always believed in the power of stories and encouraged me in my writing.

Editor Nancy Flight pushed me to rewrite and rewrite and then do it again, and I thank her for her courage and tenacity. Bonnie Evans, my longtime friend and editor, was with me from this work's inception. Agent Kathryn Mulders believed in *Windshift* and found a home for this work with Greystone. These women were backed up by helpful readers Sabbian Clover, Ruth Porter, and Dr. Lynne Van Luven. My thanks also to Coteau Books, which considered the manuscript in an earlier form, and while deciding not to go with it, acted with grace and integrity by offering their very helpful critique of its strengths and flaws.

I have neighbors and friends to thank for helping me with Connor and finding the right music for me to listen to as I wrote: Marcia Braundy, Paddy McGurin, Nancy Macek, and Don and Shirley Munro. My gratitude also to Dr. Hugh Croxall and the staff at the (former) Nelson Animal Hospital. Cottonwood Clinic, Dr. Theresa Hart and staff, were equally kind during the last month of the life of my ferocious and funny little girl cat, Dylan, who died Thanksgiving weekend 2004.

I wish to thank the family of the late Dr. Reuben Horn-stein, author of "It's in the Wind." Before his death, Dr. Hornstein granted permission for reference to his work, which was my source for the image of the windshift line.

There are writerly friends to thank—for smarts, en-durance, and spunk. Caroline Woodward is tops. Caroline and Vi Plotnikoff and I have the best writing retreats. Not only is Linda Crosfield a boon to the Federation of B.C. Writers, she is a gifted artist who put aside all else to pro-duce a beautiful hand-bound edition of this book for my fa-ther. The whole southeastern B.C. region of the federation is rich with laughter and friendship.

In the act of writing this work of creative nonfiction, I have relied on the generosity of real people whose names and stories are central to this book. My sister Judy McLaughlin stood shoulder to shoulder with me as I wrote stories that had to be difficult for her to read. Shirley Bruised Head and Anthony Steel have read and granted their per-mission as well and, in so doing, have again demonstrated their kindness and strength of heart.

My own heart has been fortified by Dan Armstrong, whose strong arms I'd happily do-si-do and allemande in for the rest of my years.

The greatest acknowledgment is to my large and ex-tended family. There are days we feel we've been hit by sledgehammers. And there are days when the laughter is so pure and sweet that it lifts like rose petals in the wind. Every person should be so lucky as to have a family like mine—the Moir-McLaughlin-Krambeer-Callaghan-Armstrong clan.

THE WINDSHIFT LINE

\mathcal{M}y father stands at his workbench making arrows. He is thirty-nine. I stand on a chair next to him, at his left, watching. I am five.

It's always cold in the basement, even in summer. I'm wearing long pants with rolled-up cuffs, a T-shirt, and my zippered corduroy jacket, the sleeves rolled up on it, too, to show the plaid flannel lining. Dad makes sure I'm secure on the chair. I stand squarely, sturdy legs firmly anchored in small red runners.

Then Dad selects an arrow. He explains that the arrows are Port Orford cedar, a very true wood from the West Coast. He dips the arrow into bright yellow paint, a contrast to the scarred workbench, the vise, and the litter of chisels. He puts the dripping arrow into a small stand.

Some shafts with their fine yellow lacquer are already dry, and he picks one to insert between the head and tail-stock of his homemade lathe.

Now I paint the crests, he says.

What are crests?

Crests are circles that identify the arrows as mine, he says, looking over to me to see if I understand. The number of rings, the spacing, and the colors are different for each person's arrows.

I nod.

He walks to the far end of the workbench, stepping over Dinty, our large golden retriever, who is settled at

Dad's feet in the inevitable drift of wood shavings. I look down at Dinty and he looks up at me; then I return to what Dad is doing and Dinty puts his head back down between his feet.

Dad has rigged a record player motor to turn the lathe very slowly. He reaches over to the outlet mounted on the front of the workbench, plugs in the record player, and switches on the turntable. The lathe, holding the arrow, begins to rotate. Dad dips a delicate fine-tipped paintbrush into a small can of red paint. He holds the bright red to the bright yellow, and a fine circle appears. Then, with another brush, he paints a green circle, then black, the colors of a Hudson's Bay blanket. He switches off the turntable, removes the shaft, sets it aside to dry.

He selects another dried arrow, shows me the trueness of the wood, the delicacy of the paint, and the three slits at the end. He inserts three feathers, untrimmed, into the grooves.

The feathers steady the flight, he says, but they're still uneven.

He places a jig over the end of the arrow. The jig holds a length of red-hot heating wire. The arrow rotates in the lathe, and gently, as each feather hits the burning wire, it is trimmed identically.

Standing perfectly still on my chair, I watch his perfect concentration with my own perfect concentration, as he takes raw material—wood, feathers, and paint—and makes them into something practical and beautiful.

I understand this about my father: he expects to show me the intricate details. He does not treat me like a child. He expects me to understand.

I don't want to run outside and play with the other kids. I am five, and I get to stand watching my father at his workbench, where time can stop, where nothing else matters but work and beauty.

MY FATHER AND MOTHER and I are visiting my brother Andy in Nova Scotia. My parents are seventy-six. I am forty-two. We sit at the kitchen table telling stories. It seems we've hardly had this kind of time since we all scattered from our family home many years ago. Hardly had times together where we really told stories.

Dad says he had worked along the Severn River, and I say I don't know where the Severn River is. He looks at me with some mixture of regret and pain in his eyes. His eyes are brown; he is the dark side of our family, the Scot. My father's dark eyes can look at a board to judge its strength; they'll size up a person. They'll size up me.

Dad tries to draw out the Hudson Bay by tracing with his finger on the blue-checked tablecloth, but it isn't working. I run upstairs, my dog Connor trying to match my stride, fetch my battered *Atlas of Canada*, the one that's accompanied me every time I've driven from my place in British Columbia to Andy's in Nova Scotia, and run back down with it before the mood is lost.

Dad touches the map as if it were a piece of wood he is feeling to learn its grain. He settles down the pages with his blunt-ended fingers, his fingernails square and weathered from work. I've watched these hands fashioning a harness for our family dog or doing delicate woodwork at the lathe.

As I stand beside him, he points to the Severn on the tattered page, where the blue water of the Hudson Bay meets the yellow landmass of northern Ontario, the papered pink of Manitoba, and he begins to tell me his stories.

There is something in this moment. It has the subtlety of glaciers shifting. Perhaps it is too subtle even to notice. Perhaps he's ready to give me his stories only if I pick up the clue that he wants to give them to me. That like any journey he's ever taken, it will involve lists and meticulous preparation.

The place names Dad points to on the Hudson Bay are unfamiliar to me, far off my usual routes. He speaks of overburdened floatplanes, fish cooked in old embers, a polar bear that circled their tent. I know I could never take it all in or remember the details, so I ask him to make the tapes.

DAD HAS WORKED on these tapes for three years. Each time on the phone since that moment at my brother's, I ask: Dad, how are your stories going? Each time he says: Well, I've had some trouble with the tape recorder. Or, Well, I'm not sure they're what you want. Or, Well, I should get some time with them this weekend.

I've almost had to pry them out of his hands, because he wasn't sure they were accurate, perhaps not complete. Kept going over and refining them, correcting little details, checking the chronology.

Now that I have the tapes I can hear what he was doing. It clicks on: Rita, you know I said earlier that it was on onshore wind? That should have been offshore wind. Offshore.

But those years as I waited, I was simply impatient. Give

me the goddamned stories before it's too late, I wanted to yell at him. Don't be such an academic. Don't be such a goddamned perfectionist. Mum told me her stories. Now please tell me yours. Don't make me beg in order to complete myself. And please, please, let me write this poem to you before it's too late.

Dad presents the tapes to me at my family's lake cabin in Minnesota. I have just arrived. It has been a long, hot drive in my old car from B.C., and after the initial greetings, my nieces, Maggie and Erin, grab my hands to haul me down to the water to swim with them. Come on! It's nice! I can go under all the way! At the same moment, Dad calls me aside in the driveway to ask me to come into the cabin. He has the tapes for me. I tell my nieces I'll be down to the water in a minute and go inside with Dad. He walks over to the staircase, a dark corner past the fireplace, and picks up an old cardboard box.

I hope this is what you want, he says.

We're alone in the living room. Mum's in the kitchen.

I dig into the tattered box. There are seven tapes, some in cracked and scratched cases. Some are new.

I've set out the topics for you, he says.

As I unfurl the curled pages of lists, Maggie and Erin yank open the screen door, their young bodies dripping with water: Aren't you ever coming?

I thank my father and tell him how much these tapes mean to me, how grateful I am for the care he's taken.

We could listen to them now, he says, in case you have any questions.

I tell him I can hardly wait to listen, but I promised the girls.

I know he thinks the girls can wait. And I know I am just making excuses, as if this is a suddenly uncomfortable and intimate encounter at a party and I want to make my exit. He wants me to sit and listen to his tapes with him, all seven hours, minute by minute. But I can't. I cannot imagine sitting and listening in such close proximity. I can't handle the emotions, the exasperation, or the boredom. My father is handing his stories to me, his life, really, and I don't know if I can do it. If I can bear his scrutiny. The bargain is sealed, but we never really negotiated. What will I do with his stories? What do we each expect from each other? And will we measure up to our unspoken expectations?

I can't listen to them now. I have to carry Dad's tapes away until I have time and solitude. Mum understands. To the disappointment in his eyes, she says, Ross, she has to have the time to take them in at her own speed.

DAD APPARENTLY has decided I'm worth the risk. I am, after all, a journalist. He knows I will dog a task until it is done. He knows I am the one in the family who will complete this part of his life. My brothers and sisters will carry forward his other roles, as carpenters and gardeners, cooks and orators. At times we will all assume his command and control, glare out from his piercing eyes. But I'm the person who will write his stories and make them my own.

We leave the lake and return to St. Paul, where my parents live. Dad asks me to come upstairs, where he stoops

down to the shelves below the windowsill. He pulls out a thick volume, the original of his doctoral thesis. It is dark green and hardbound: "A Floristic Study of the Severn River Drainage Basin of Northwestern Ontario." Downstairs I ask him to inscribe it, but at first he doesn't know what to write. Mum prompts him and he writes my name, then signs his own with all his love.

I hug Dad and thank him, and later in my room next door at my sister's, where I always stay, I open his thesis carefully, look at the title page from 1958. This thesis was submitted to the faculty of botany at the University of Minnesota in November 1958. The lists of illustrations and tables look dry and difficult: "A high oblique aerial photo of beach ridge development near the Hudson Bay coast," or "Black spruce muskeg on deep peat, Sachigo Lake."

I leaf through the pages, catch the old photos and maps—beach ridges and walls of varved clay, like bricks laid and stacked by the glacier, rivers and tributaries of the Hudson Bay Lowland. The photos fall from dry and yellowed glue and slide from the pages. My father took many of these pictures, of spruce bogs and game trails. Others, the aerial shots of river mouths, their channels and islands, he credits to the Royal Canadian Air Force.

So this is the north where he spent so much time when we were children. This is where he came home from, carrying the dripping bags of plant specimens. His homecomings meant canoes repaired and drying in the backyard, men in khaki, with beards, laughing and tired as they walked down the sidewalk. The names of fish and plants spilled

from their mouths. Lovely words that I now can imagine remembering. Lifts of fish, wind-trained trees, *Arctostaphylos uva-ursi*.

In my father's text, there is so much botanical identification, in Latin, that I don't trust that I can force myself through it.

Sphaerostachya. I trip over it. Try it again, as if it's Russian.

Heracleum lanatum, Oxycoccus microcarpus.

Then I hear my father's voice, the rhythms he would use. A kind of rocking, teasing voice, having fun with the syllables.

I'm going to pick some corn, Dad!

Spermatophyta. Monocotyledonae. Zea mays rugosa!

I wonder if kids of Catholic families feel the same when they celebrate a mass in Latin. Perhaps, like me, if they grew up hearing the language, they surprise themselves by pronouncing the Latin correctly, finding the rhythms, as if it is an undertone vibrating in their bloodstream.

I whisper the words to myself, tentatively, the language of a secret culture that's been available to me all my life. I just had to open the door.

Rosa acicularis, Cornus canadensis.

My father knows these words and the world they came from. He's giving me his books and his stories. I can stack them in a dusty heap, or I can open them.

Equisetum sylvaticum, Arctostaphylos uva-ursi.

There are pages and pages of Latin names for his northern world. He knows the details, and the large world these details can build. The plants were his entry. They helped him delve into mysteries and cold places where it was difficult to

go. They helped him learn the ebb and flow, how to marry intense detail and the long view, how to step back and breathe. How to disengage and take stock.

Epilobium angustifolium, Linnaea borealis.

I want to know my father better, but I also simply yearn for my father's knowledge: I want to learn his ways. How he could come and go. How he could be so absent, or be so present. I want his strength to imbue me, to balance me and give me distance when the forest or strong emotions begin to close in.

I turn the pages. Some lists sound rich and full, sensual—*Aralia nudicaulis, Actaea rubra, Thalictrum venulosum, Fragaria virginiana, Rubus pubescens, Mertensia paniculata, Petasites palmatus, Habenaria orbiculata, Clintonia borealis.*

Later, I will ask my father the meaning of these words. But right now, I just want them to be mine.

WIND-
TRAINED
TREES

1997

\mathcal{I}rene, the owner of the Fort Motel, embraces me quickly, then gives me the key to Room 15. This motel, the bright oranges in its rooms, warmed me once on a bleak day, and I haven't forgotten. Room 15 is duly equipped with a kitchenette—fridge, stove, pots and pans, the whole thing—but it's all beiges and bland and doesn't get the afternoon sun, which I need on this cold November day.

I resign myself to this disappointment and unload the car. It's strange without my big dog trying to push his way out. Connor died yesterday. It's unbelievable that there is no Connor anymore. All the movement of him, all the curiosity. Gone. I set out his picture, the tape deck and laundry basket and the books I've brought, some familiar and some new. Everything. All my props. And each time I walk into my room in Fort Macleod and see the bland neutrality of it all, the beige curtains, the brown bedspread, I think, "Well, it will do," and then I think, "It will do" isn't good enough right now.

I want sunlight, the color orange to warm me, something special when I walk in this door.

Irene offers me another key, to Room 20, where there is no kitchenette, just a small fridge, but where sun floods the room. Above the bed there's a large framed photo of the Alberta coulees bathed in storm light. A tree stands on the lip of a coulee, the wind in its branches and the grasses around it orange like golden fire. Irene comes in the open door: It's

the Burmis Tree, she says. You passed it on your way through the Crowsnest. We stand together looking at it. I can see the push of the wind in its trunk, how it bends but doesn't fall, how it grows stronger in the wind, and think of a term my father uses. It's a wind-trained tree.

In Room 20, there are bright orange towels, a bright multi-colored bedspread, and embossed onto the desktop, a map of the world. I smile and think, "Fuck the kitchenette" and drag everything over from Room 15.

I BROUGHT MY FATHER'S tapes with me, his stories of exploration: the lakes of northern Manitoba and later the Hudson Bay. I hope the work of transcribing and learning new terminology, the discipline of the start, stop, write, replay, will help me escape, give me structure, take me someplace far away. I want his accounts of botanical expeditions, portages, and swift rivers. His descriptions of trees sculpted by the force of the wind—wind-trained trees—and his studies of the land after the glacier receded, the crustal recoil after glaciation.

I've brought my own books as well. In one, I've found the term *windshift line*, and I want to explore that, too.

I crave stories of distant places. I want something to pull me away, something Calvinist, unemotional, cold, and distant, something as clear as amber, stories as old as pollen in ancient peat bogs.

In this room, I need to make a construct. On my own, and with my father's distant help, I plan to sort some things out.

The tape deck sits on the map of the world. Above it, on the wall, I pin up a map of Manitoba and Ontario so that I can see the Hudson Bay. My eyes range the vast lands my father traveled as a young botanist in 1951, '52, '53, and '57, collecting plant specimens.

Next to the tape deck are the lists, in capital letters, of topics Dad has included on the seven cassettes, lists wrinkled and curled from being held with an elastic band.

I unfurl the papers and hold them down with Connor's photo and a box of paper clips: PEAT BOG ANALYSIS, LIFE ON TORONTO STREET, CHURCH, MICROSCOPY, CHEMICAL SERMON. The lists go on for seven pages.

Had he written them years ago, he would have pulled his chair up to his desk in the botany department. His hair would be thick and dark and wavy, his posture casual and competent. Wearing his white lab coat, he would refill his fountain pen with an ink-filled hypodermic syringe. The capital letters would be small, square, sure, perhaps their imprint made on vellum.

But these lists I look at now he made using a heavy felt pen. The letters are large and shaky, written on the back side of cut-up Dakota Maid flour bags. My father, who once cooked his own bannock over a campfire beside the Hudson Bay, now bakes in his bread-making machine at the lake, and these lists, like the tapes, he made where he sits long hours in his recliner at the cabin.

My father's tapes begin exactly as I feared they might. Not with exciting stories of his work in the north but with a long, detailed setup, laying out academic qualifications and

rationale and lists of books for me to read, books that lie on the dusty shelves in my parents' upstairs bedroom.

Tape #1 begins by recommending books about the prairie. Moldy, dusty-sounding government publications like *The Ecology of the Aspen Parkland of Western Canada*.

"This was written by Dr. Bird, who was formerly the superintendent of the entomological station in Brandon," my father says.

My Dad was Dean of Science at Brandon University, so he probably knows these people, and he loved this prairie, its vast stretches, its pockets of spruce and deer. But I am aching for adventure, for tales to take me far away, and it is so hard to bear this detail.

"This book by Dr. Bird was published about 1966, but it's really an excellent little book in that it gives a good bit of information about the travel through the plains area of Manitoba, Saskatchewan, and, I believe, Alberta.

"Dr. Bird goes into some detail of [here the tape clicks off and restarts as Dad clears his throat] well, the nature of the land before settlement. The aspen parkland was the fringe area between the grasslands and the coniferous forests and a good bit of this lent itself to agricultural development. It was a mixture of aspen woods, uh, sloughs, uh, small ponds, but the nature of the glacial till and the topography, uh, made it, with clearing, available for agricultural use."

Oh dear, my Dad is lecturing to his students. He has forgotten that I am his daughter and these tapes are supposed to be our family stories to pass along.

He finishes with Dr. Bird and the impact of pre-settlement vegetation, the impact of the railroads, and definitive

lists of vegetation, which he thinks may be useful to me. He mentions O.E. Rolvaag's *Giants in the Earth*, an authoritative history of glacial Lake Agassiz. A long history, no doubt.

But then Dad does move on to tell me about his relatives. I have very little sense of his family, since his work moved us away from Winnipeg, gave my parents the chance to make their own lives outside the confines of family, outside conservative, stifling 1950s Manitoba.

"Next I should record what little I know of my own family history," he says. "I'm almost embarrassed by how little I know. By the time I was interested, there was no one left with the answers."

It's interesting to hear these details of who married whom, how they originally came from Scotland. But his way of speaking is as interesting as the information itself.

When he talks about his own father, he speaks with precise imagery that stirs my own flat-lined imagination. He describes how one Sunday each month his father, a strict Scottish Presbyterian, sliced a loaf of bread, cut the slices into cubes, then carried them to their church for communion.

His father was a farm mechanic who worked throughout western Manitoba. He would test the blade of the plow he had sharpened to make sure it would turn a very correct furrow. He would polish it to a mirror finish so that it would properly lift the heavy clay soils of the Lake Agassiz Bed, the bed of the old glacier. I shut my eyes, see the wave of clay lifting, the bed of the old glacier rolling like combers on the ocean. I see the mirror polish of the blade flashing sunshine, folding over the earth.

There is something in hearing my father from this distance that is different from everyday talk. It is far more thought-provoking in some way, gives me time to sit quietly and listen, without the normal back and forth of conversation and interruptions. He has prepared and thought these things out for me, and he presents them in a manner more formal than if we were simply in a room together talking. There is a Presbyterian exactitude to the words, a crispness and factuality that does me good. But they are pretty, too, though he is given more to the precision of scientific language than to poetry. His precision allows me to close my eyes and imagine.

He speaks of the glacier, or the glacial soils, and I realize that to him, the glacier is not just history, words in a musty text, but the ground he walked on. It is the soil his own father turned with a sharpened blade. It is part of his everyday vocabulary.

I begin to listen more closely to the language.

There are proper names like Wekusko and Cranberry, the lakes my father traveled in northern Manitoba; there are pungent words I grew up with, like *muskeg* and *tundra* and *base camp*, and terms new to me, like *lifts of fish*. I play with the words, imagine the sight, the water streaming off the fish as the men lift the gillnets from the water.

On the map above the desk, I look far into the north and find the Wekusko and Cranberry lakes. Trace the route with my finger. Follow it over to the Hudson Bay.

On the tape, his voice speaks of pollen preserved thousands of years in the highly acid peat in the bottom of the

bogs. The pollen tells the story of ancient plant life and of the encroaching and receding glacier.

I imagine the forces of water, glaciers, the reality of canoes and portages. Of unexpected pleasures. The company of strangers. The beauty of voices. The language of the Cree, the Latin of his work. I look at his thesis, which was written when I was six years old. I leaf through his descriptions and lists. *Arctostaphylos uva-ursi,* the bearberry. *Epilobium angustifolium,* fireweed. *Linnaea borealis,* twin-flower, *Linnaea* for the botanist Linnaeus, who often wore a sprig of twinflower in his buttonhole; *borealis,* a plant of the northern forest, from the Greek name Boreas, god of the north wind.

How strange and delicious to speak this language I heard as a child, to sluice new words around my mouth, as if doing a vocal warm-up or learning the taste of wine. How strange and wonderful to read this work written during my childhood; to imagine my father at his work as I am now at mine.

WHEN I WALK DOWNTOWN along Fort Macleod's broad prairie street to the Silver Grill for supper, I take my notebook with me. I am a journalist, an explorer. My notebook is my companion. The minutiae of my surroundings, the recording of them, are my justification for being, the identity that will keep me going. Eye-hand-paper-brain. Scratches and sketches. My father did this. The botanist. Observer. Quick outlines of trees, grasses, wildflowers. Block letters in Latin. Chores and distance and notebooks to create order, to cool the emotions, like a wet facecloth to cool my swollen eyes.

I chose the Silver Grill because I read a story about the mysterious holes and cracks in the big mirror over the bar.

The voice of Ian Tyson, singing about the woman whose cowboy loves his damned old rodeo more than he loves her, greets me as I push through the front door, and I pick up the tune and words in my head.

An overhead arch—a grille of silver lattice—spans and divides the restaurant between front and back. Like a silver sunrise, it beckons my eyes upward to the pressed tin ceiling, one of so few left to admire across the country.

I look around, nod to the few families at their tables, to a couple fellows in baseball caps, and to a Chinese woman and her little boy, who in their ease here so clearly proclaim this place as their own. We smile at each other, and she waits for me to settle.

Over the years of being a reporter, I have learned not to be self-conscious about standing quietly and observing. I don't always have to be busy but can just take things in, let them wash around me if I can be still enough.

A wooden bar runs the length of the room. Behind it the cracked mirror looms large. The holes I read about are dark, smashed wounds; four cracks radiate from each. The damage was severe, but the mirror, old and worn now, holds.

The woman brings me a menu as I touch the swivel seat at the bar, run my hand down its back of white woven cane.

Back home, when Connor got so frail, he fell against the cane rocker. The rocker toppled against the mirror, which shattered as it crashed to the floor. Connor tried to bolt, but his old legs wouldn't hold him. I helped him, righted the rocker, picked up the shards.

Across from me, below the mirror, is a large fish tank, and I'm attracted to the swirls of orange and black bodies, swishing fins and tails. The tank sits on a row of old wooden fridges, dark and empty now, the kind I'd like to open and explore.

I order some wonton and egg rolls, and ask the woman for the pamphlet giving the history of the restaurant and the mirror, enjoy the comfort of something to read, enjoy being an outsider.

The history, on faded blue paper, says that sometime around 1912, a man on horseback burst through the front door, shot the tops off bottles beneath the mirror, demanded the liquor, drank it, then wheeled his horse and rode away.

Flashy enough. But it is the mirror's story, not the rider's, that captures my imagination. I look up at it, marred and tarnished now, imagine it cracking, as if it were a vast sheet of ice. People stand in shock, listen to the pistol shots of its breaking long after the horseman has reholstered his gun.

The cracks reach out to a heavy scrolled frame. The silver scrolls are caressed by the red tassels of a three-tiered Chinese lantern that hangs above. The lantern spreads orange light across the mirror, and along the edges, pastel Christmas lights blink off and on. It all seems right and comforting somehow, this contrast of old and new, the broken and aged within the comfort of warmth and color. I open my notebook and begin to sketch.

A little boy is running from back to front, but he isn't disrupting anyone, just adding some life to a slow, cold Sunday evening. He asks his dad to lift him onto a stool beside me so we can watch the fish swimming around the tank

together. He counts out three that are orange. One is all black, its feathers riffling in the water.

The boy tells me his dad is a school teacher, and he looks to his father, who identifies the fish for us: goldfish, Japanese speckled koi, *Plecostamus*.

The boy looks at my notebook, asks what I'm doing as I draw the counter and mirror, scrolls and lanterns. I tell him I'm drawing pictures, just for fun. Satisfied with this answer, he returns to his family's table.

I lean against the bar and look down its length, like you do when examining a board for straightness and grain, bends and knots. All one piece of wood, eighteen inches across, a substantial expanse to lean on.

I like being here, being a traveler and not a mourner, and wonder if I can be both, wonder if I can move myself to images and places already established, old, told and retold. To sense the relief that someday, simply by going on, the edges of my own sorrow will be smoothed; one day their rawness will be planed down as this counter is, after many hands have held to it, found comfort and certainty, found their own reflection in the scarred and beautiful mirror before them.

When I leave the Silver Grill, I am fortified. I am making my base camps alone. This time they are a Chinese restaurant with a pressed tin ceiling and a motel called the Fort. I can be alone here but in this warmth and color and these voices not feel so lonely.

THE WIND FROM THE WEST helps push me down Main Street to my room, where I get into my pajamas and climb into bed. From the pile of books beside me, I select the

orange and green one, my battered copy of *Trinity* by Leon Uris. I got my dog's name there, from the hero of the story, Conor Larkin. I misspelled the name but kept it that way. Connor, named for a big dark-haired Irishman from County Donegal. As I brought Connor home from the vet's where he'd been left to his fate so many years ago, I turned to him in the back seat: Your name is Connor, and you're my dog.

And for fifteen years, he was.

I open the book, reread the first pages: "Conor ran like he was driven on a wind . . ."

*Y*ou know how it is when your old dog struggles to get up? You speak firmly to yourself. You say, when the day comes when he can't . . . and then you name the benchmark. When he can't run and enjoy himself. When he can't get up the steps without help. When he falls against the rocker, which hits the mirror, which falls and shatters. When he shits in the house.

But that benchmark comes. And it shifts. Because, of course, with help, he does get up, he does run, he does shine in the sun, the obsidian planes, the feathers of his big setter body lifting in the breeze. He is my big black beautiful dog, Connor.

He is, was, sixteen and had been with me longer than anyone. I dreamt of him often before he died.

In these dreams about Connor, buffalo and elk swirled around us. The animals laughed at me, barged around and roared off chortling. Sometimes Connor chased them away, his old body struggling over monumental obstacles, the Frank Slide, large prairie. Sometimes he walked away with them. Once he swam a wild river to help me when I was in trouble.

It was odd to sit at home on the couch with him beside me, planning what I would take to southern Alberta after the vet put Connor to sleep in Nelson. So strange to plan how we would leave our log house in the forest, the home we'd

left and come back to so often together, sometimes in joy and once in fear, and know I'd return alone.

There was never any question that when he was dying I would give Connor the same love and attention I would give to my family and friends.

In his last days, Connor wanted me next to him always, on the couch at night, him with his head by my leg, me with a book in my hand. He didn't like guests much anymore. He fell a lot. We'd gone the route of anti-inflammatories and aspirin and getting his weight down. It was just time, that's all, and I needed to resolve the when and where.

I stroked Connor's head and planned to take his picture with me. To take a wet facecloth in the car because already my eyes were so swollen and chapped from crying that only cold water soothed them. I am thankful my practical side helped me, making the lists to see me through, give me purpose and backbone.

I told my neighbor, Marcia, that I had finally made the decision to put Connor down, and while I escaped for a few hours to do errands, glad for some practical chores in town, she took him for a walk to the river. That night we sat drinking Kahlua and vodka, toasting Connor and feeding him all the chicken burgers he wanted. I spent the next few days with him, going for short walks or watching my cat, Dylan, wash around Connor's eyes with short rough cat licks. I prepared and packed, told friends, called the vet.

The last night, Connor was so restless. I got up three times to help him outside. Finally, I sat through the night, reading and stroking his head. In the morning, I packed the

car, threw in a wet facecloth for my red and swollen eyes. Connor rallied, was all anxious for the trip, romped through the woods in his excitement to go in the car. I packed a photo I took of him on the shores of the Bay of Fundy, long hair rippling in the wind. It was so strange even to plan to take his photo with me, knowing it would be all I had left of him when I drove away from the vet's. To think of him in the future past when he was so present. I phoned my brother, Andy, who had just put his own dog to sleep.

I've decided on cremation, I told Andy, so I can take Connor back to every place we ever visited, cast him to the winds of the prairies and the oceans and rivers, return him to every spot he's ever marked with a lifted leg.

ANOTHER NEIGHBOR, Paddy, went to the vet with me. Connor was beautiful, walking in the sun. The people at the vet's couldn't have been better. I asked them, these same people who gave me Connor fifteen years ago when he was so young and headstrong, to explain everything. I hadn't done this before, and I needed to know exactly what would happen: Would he jerk? Would he cry out? They explained how fast it would be, then helped me lay him down on the floor on his old sleeping bag. I lay beside him and held him. They put in the needle. He died quickly.

I curled around his big back, the way we slept together for so many years. There was a pool of his urine on the sleeping bag. I got up, got handfuls of Kleenex. Paddy and I cleaned him up. I lay back down with him. The vet staff came in and out of the room, going about their routine.

Take your time, they said again. Soon, as happens in these moments, I was propped on my elbow petting my dead dog, chatting with them, and asking what cremated remains were like. The vet got some ashes of another dog to show me. As I sifted bone and ash through my fingers, the vet leaned back against the counter, crossed his arms across his big-barreled chest, and began what can only be called a shaggy dog story. He told me at length how he had, at the request of a dying friend, later cast his friend's cremated remains to the river. I went to Calgary, he said. I took the urn to the river. It was a beautiful day with a breeze, and I threw the ashes into the wind. They went up and into the wind and sun, then the wind turned, and the ashes blew back, right into my eyes. They stuck there for a month.

Don't throw his ashes against the wind, he said, smiling down at Connor and me.

Paddy and I left Connor, walked out into the cold, then headed downtown to the Main Street Diner, where I brushed my teeth, scrubbed my face with the lush green facecloth, brushed my hair. We had some lunch, like you do; you have to restore yourself somehow. Something warm, in the small familiar diner, surrounded by sound but in a small private world, too.

I gave Paddy my leftover chicken burger for her dogs, and then we headed down the street. At the drugstore across the way, we examined bottles of purple speckled nail polish. Paddy stocked up on chocolate. I bought acetaminophen with codeine, the 200 size. The druggist looked at my bloodshot eyes and told me that they didn't sell bottles of

500, and that it was best not to take too many. Paddy and I looked at each other, at our tear-bloated faces, and started laughing. She passed me some chocolate.

Then I said, Oh my god, Oh my god, and bolted back to the Main Street Diner, into the warmth and steam of it. I said to the waitress, whom I know in the way of small-town familiarity, about how it was a great meal, I should have paid for it. Then in the midst of the noise of the restaurant, I told her about Connor. I searched for the word. I'm . . . stupefied, I said, and she put her hand on mine just for a moment, just long enough.

WAITING FOR THE FERRY across Kootenay Lake, I cleaned out my pockets. Took off my leather jacket to dig out wads of soggy Kleenex. Six paper clips. Three Band-Aids. Twenty-four buttons that say I Support Seniors' Housing. Set them all on the dashboard. Then I held the jacket upside down and released the lint and grit.

My dog died today, I whispered to myself.

Funny how on the ferry, in the sway of the water, my hips felt lighter, yet strong. My breathing deeper. How I simply looked at people, made no attempt to smile or talk. Just looked into and through, stood alone, feeling okay. Distant and disconnected.

I'm glad I took the ferry across the big open lake and didn't drive the mountain pass. I hate that fucking mountain pass. I hate how it presses in on you, how you just have to keep climbing, just push and push just to get up and over before you find wide open spaces. I don't feel like conquer-

ing anything more. I don't want the goddamned up and over, just the over.

I TRIED THAT NIGHT to drive the seven hours to the wide open spaces of southern Alberta, but it was too far. I'd cried so hard it was dangerous. It was wet and dark and November 20. I aimed for Fort Macleod, thought I'd make Fernie but only got as far as Cranbrook. I called all my family, in Nova Scotia, Manitoba, Minnesota. They all knew Connor as their own. Dad was crying, too, when he said good-bye, and then I sat alone in that motel room and consoled myself with the tape of Rawlins Cross, the bagpipes of "MacPherson's Lament."

The next morning I pressed on to Fort Macleod.

*I*n the early crisp prairie light, coffee fresh and hot, I open my father's thesis about the Hudson Bay. I look to the Hudson Bay on my embossed desktop map of the world. I feel so exactly right, so happy to be where I am. As if I am a student: my tools, fresh paper and old texts, before me. A job to be done.

On page 29, Dad writes: "Below the junction of the Fawn River" (I look to the Fawn on the bigger map of the Hudson Bay up on the wall), "where the Severn" (find the Severn) "has cut down to the underlying bedrock of Silurian Limestone, the river has a very youthful character.

"Its banks are steep and often precipitous, with glacial clays forming the under layer and marine clays of more recent deposition forming a surface veneer of variable thickness and distribution."

Yikes.

I struggle through the language.

The river's banks are steep and often precipitous. I read the passage again and again. Approach this first test of my ability to move from my father's dry and scientific text into my own imagination. Then I see the steep banks and youthful river, its danger and daring, its rawness cutting to the bedrock.

Dad writes that the Severn and Fawn rivers, south of the Hudson Bay, "have long been traveled in connection with

the fur trade and even up to fairly recent times have been an important waterway for canoe travel."

He writes that the Laurentide ice sheet of the Wisconsin Glacier covered the entire area, a great sheet of ice originating in the northeastern part of the continent, beginning as valley glaciers and eventually covering 5 million square miles.

I can't comprehend 5 million square miles. Can only conjure the image of endless white, of huge animals, musk ox and woolly mammoths, their heads and shoulders bowed to the wind and snow. I imagine endless time, an endless search for food. I imagine the shrieking wind and the comfort of days when the wind stopped.

I think of Dad, how he came home from his explorations, his endless searching, taking a break and regrouping. How he came home wind-tanned and strong. Bearded, khaki-clad. How, the Christmas I was four, he made a dog harness with wide leather bands. I remember the strength and the dexterity of his hands as he worked and worked the heavy leather, padded it with sheep's wool, laid it over our dog, Dinty's, back and buckled it under his big chest. How Dad built us a box sled with low sides to hold two small children who could maneuver the reins as the dog pulled us across the snowed-in river flats. I admired how he always tried things: I remember how we watched Dad working on the house or making a stone fireplace in the backyard. How he pushed the wheel hoe in our garden by the Red River.

My father was the outdoors; it's where he lived best.

On the tape, he tells me how, as a visitor at a Hudson Bay post, helping to unload a supply ship, he hoisted

hundred-pound sacks of flour onto each shoulder and hauled the two hundred pounds up the ramp from water to land. He tells me of the days in northern Manitoba when he and his partner portaged their eighteen-foot canoe, fighting water and wind.

My father's story continues, taking me back centuries. Eons. He tells me how air masses from the Gulf of Mexico, and from the Atlantic and Pacific oceans, converged to nourish the glacier. The oceans' moisture-laden air met the cold air off the ice sheet, their masses clashing in great turbulence, the power of their collision causing great snowfalls. The snow falls and the ice grows—until it is five thousand or ten thousand feet deep. The ice is so heavy it causes the earth's crust itself to depress, so heavy it deepens the Hudson Bay from a mere lowland to a great inland sea.

I imagine this power, of winds and snow, of the earth deepening, weighted down with its massive burden of ice. And in my chest, I feel my own self caving in, as if here alone in this room, I am suffocating. Although my father is frail now, can stumble so easily in his own back yard, at this moment he is strong beside me, and here, on page 33, with his words, he helps push back the weight. He tells me how the earth's crust begins recoiling, rebounding from this burden of ice. With my father beside me, I make myself breathe and breathe, slowly and deeply, try not to gasp for air, feel my own resistance begin, begin my upheaval, push back the crushing ice with all the force of my shoulders, twist so I can use all their strength, put my back to the glacier, push the ice, push the ice, to give myself air, fill my chest with its sweetness.

He promises me that when the weight recedes, new life begins to form. He tells me how new beaches form, ridges that grow as the earth recoils, how the very crust of the earth begins springing back in glacial meter.

As he gives me this moment, where we stand hand in hand looking back across the centuries at the earth, it's as if he is offering me the power of creation and re-creation, and my breathing regains its ease.

I WALK AROUND my room for a while. Throw out a coffee filter full of grounds and stand the books up properly by my bed. Then I pull off my sloppy morning clothes, sharpen myself up with clean blue jeans and shirt, ready to stride downtown.

A Connor kind of puppy, silky black, tugs at his leash while crossing the wide street by the theater. It doesn't make me sad, even makes me smile again. I'm glad to be alone for this, and I welcome the chill, the cold and wind I want to anesthetize me.

I am a single woman and my dog has died. That's the simple truth of it. My dog has been with me when no one else was. That is the reality. On almost every adventure, Connor has been with me, and I am not certain I can do this alone. Without his insistence on exploring back alleys, on long walks by the river, or racing across an icy park in the wind and snow.

For a time I prepare a briefcase of data to justify my emotions, to convince a skeptical jury that my sorrow is valid. I quantify my sadness by counting the actual hours we spent together, the days and months and years. Around the

clock, through the traveling, through all the changes. Fifteen years. Multiply that by days. Then by hours. 5,475 days; 131,400 hours. The accounting staggers me, adds up to more hours than I've spent with anyone else, even my own family.

But then, I let it go. And for one of the few moments in my life, I know with all certainty that I don't give a damn what anyone thinks. His death belongs to me. No one else gets to decide anything about it. I will mourn him until I am done mourning, and to hell with anyone who tries to stop me or belittle me on my way.

I know he's "just a dog." I know there are more important issues in the world, and I know this emptiness and how it undoes me would seem ludicrous to anyone else. That's why I need to be alone. I need to stop the world, so I can take time to figure things out. There's mourning and there's what's beneath it, not just the loss, but the future and the fears the future holds. I need to figure out how to live alone in the world.

"AIR TRANSPORTATION was very expensive," Dad says, "but we worked out a cooperative arrangement with the Ontario government."

I like how these arrangements get made. There is some ease in the currency I admire.

They had a de Havilland Beaver in service in that area, a very fine bush plane with a load capacity of seven hundred pounds. In exchange, I'd bring along any of their personnel. One time it was a vet studying tularemia in the beaver population. Another summer we had the equivalent of a forest ranger who was studying woodland caribou. They were very

cooperative in getting us in when the season started and out in the fall.

My father and his co-workers climb into their canoes, travel the salt marshes of the Hudson Bay, the largest inland sea in the world. They explore the newly formed beaches, which are separated by long parallel depressions. These depressions are caused by the action of the waves, the receding movement of the melting glacier, and the lifting motion of the earth's crust. Farther and farther into the interior they travel, the beaches becoming less noticeable as the vegetation grows thicker, masking the depressions, weathering the ridges.

I see the swift youthful rivers racing and carving their new paths, and the slow rebounding of the earth as the heavy weight of the old glacier recedes. The earth breathes, forms new patterns. I inhale and exhale in glacial meter, count the beats, imagine the silence. The earth uplifts from its heavy burden, forms new surfaces, makes way for fast rivers, and regrows.

SOMETIMES MY FATHER'S formal, even obtuse, language amuses me. He makes it sound as if, in their northern explorations, a Greek god directs their work—the great deus ex machina that controls their efforts, their direction. "Little opportunity was afforded to study these features in this area"—he will say about any area they were not able to explore.

I would like to say this in my life whenever I cannot make my way in, when I can't delve or understand: "Little opportunity was afforded to study the features in this area."

For a day or so, I entertain the fantasy of relocating from British Columbia to Alberta. I imagine starting over again, even if for a year, to forestall the return to my empty house in the closed-in mountains. I love the wide sweep of southern Alberta. I consider renting a huge suite, the whole second floor of the old Canadian Imperial Bank of Commerce, a downtown corner of Fort Macleod that looks over the prairie.

I walk into the saddle shop on the old bank's main floor.

A man working behind his bench looks up and smiles. His dog stands up from its place at the man's side and walks over to me, slips his nose into my hand, pushes up, his head just at ear-scratching height. The dog's request—and my response—is so familiar, so unspoken, that my eyes well up, even as I try to hide my emotions from this stranger.

The dog's name is Chuckie, he tells me, looking down at his work, giving me a moment with the dog.

In that shop, alone with the man and his dog, I can say what I need to start saying aloud.

He's like my dog. I put my dog to sleep the other day.

Then the man stops his work, comes out from behind the counter and puts his arm briefly across my shoulders.

I STAND STARING at my desk, my tape deck and transcriptions. I thank my father and myself for pushing through—for the work ethic that finally triumphs. My father's stories now are my lifeline. They are so certain. So complete with their sheets of ice and lifts of fish. They secure me with their wind-trained trees. All images are solid and fixed. Even

change is slow and steady. Even swift and dangerous rivers are accommodated.

I don't want to sleep at night. There will be no dog by my side. In sleep I will lose my father's steady images. In sleep I cannot accommodate swift rivers, their dangerous slopes.

*A*t night, the man I lived with comes after me across rivers. From these nightmares I wake shaken and dispirited. At each waking, Connor is there to receive me. Sometimes, at the last moment, I outrun this man, a friend pulls me into safety, or Connor stands barking, protective, as I cross the river.

In real life there was no protection. The man kept calling. He called my friends. He wouldn't let go.

Even now I find this hard to recount. It is staccato and jagged. It doesn't fit with taped stories and glaciers. It has no place in poetry or music or the sunrise of a prairie morning. This story has no air to lift it, no strong shoulders to help bear its weight. It's in a strongbox, though at times I lift the lid. I still distrust my own version. Over the years, however, I have come to realize that nightmares tell their own truth.

I judge myself harshly for not knowing better, but at the time I was drowning, the currents too swift, the undertow deceiving.

WE MET DURING a political campaign, the first time, I think, at a planning meeting in a union office, and another time at his home. I thought he was smart and witty and confident, and we began to talk often on the phone. For one year we worked relentlessly for our local candidate in a provincial campaign; we met impossible deadlines, dug in through the

controversies, and rode the jubilant waves. When our candidate lost by a handful of votes, we were devastated, but we had worked in sync with each other and our friends, day and night, for something we all believed in, and we still had each other. Before the year was out, he moved in with me. I wanted him to. We were in love. I loved his calmness, his self-assurance. I think I loved that he loved me.

I had resolved early in life not to have children. Like many women of my age, I believed I had a choice between being a homemaker or taking on a bigger world, and I chose the world. I did not experience a ticking biological clock and did not regret my choice. But this man did have children, and during a crisis with their own mother, I agreed, probably suggested, that they come to live with us. They needed the home I could offer, and I was ready to help. They began to accept me, and I grew to love them. Connor, big and solid, was there for them to love, curl up with, run through the woods with.

I believed that this man and I were meant for each other so much that I took him and one child halfway across the continent to meet my family.

I CANNOT USE his name. I still need to keep this morality play at a distance, to hold him off with one hand while I sketch him with another. I need to make him evil, perhaps more evil than he was, while I draw some lines, define the issues.

Sometimes in this tale, he drank too much. Eventually he told me that alcohol was a family issue. Him, his mother, his wife.

Even now, as I recall this years later, my throat tightens, my chest constricts. I need my father to help me lift the glacier pressing down on me.

All right, then, let's roll up our sleeves and deal with the alcohol issue. With love and hard work, I thought (oh god, how naïve I was), there is nothing we can't fix.

Oh, wind-trained tree, don't bend to breaking.

But of course I couldn't fix it. There is no fixing a drunk.

When I took him to meet my family, I could see in my parents' eyes that they thought there was something wrong. He was too ingratiating. He drank too much of their booze as they slept at night.

Oh, swift river, I cannot swim in you.

But I needed to be loved. I had lived alone for three years, and it was enough. I was ready to give and be given to. I wanted to share all my love; I wanted to make a family. I opened my heart completely and in turn, expected him to be my brothers, my father, my confidante and lover all in one. And he in turn, opened his heart to me; he told me his loves, he told me his losses, he told me all the sores and complications. It's what we all do when we open our hearts.

But it was not long before I learned his mantra, the confessional score for the years we spent together. All that was wrong with his life came from women, he told me in so many ways. His mother, his wife, his co-workers.

I worked, I did, to understand him and to talk to him about the lives of women. I worked so hard that I smeared my feminist lens, to understand and rationalize his anger. Hey, I seemed to be saying, against all my better judgment, You've been screwed over by women since birth? I'll fix

things. In my family we fix broken things. We work to-
gether, or at least we go down trying. We take care of each
other and we fix the problem.

You'll see, I assured him, I'm different from any woman
you've met.

AND I DID become different.

*Wind-trained tree, your boughs are too heavy, you are
breaking.*

I became a woman who took care of his children while
he went off to work; I was a woman who lost contact with
her own friends, who, unencumbered by proximity, could
see clearly what I had bought into.

I began to apologize and explain on his behalf.

Then his financial dealings became complex and bizarre.
I believed that my own finances were so simple that I just
didn't understand the world in which he existed.

Then it became my fault if he was drinking.

But of course I kept trying to make things right. Things
can be made right if you only work hard enough, care hard
enough.

Then I became a woman who cried every morning, and I
knew deep in my sturdy 4-H girl's soul, that that wasn't me.

*Oh glacier, oh father. The ice is too heavy, the depression
too deep. I cannot breathe.*

We were in my bedroom together, upstairs on the sec-
ond floor. His kids were in the next room. It was night in my
home in the forest. From my bed where I sat with Connor
by my side, to the few feet away where this man stood, his
constant low rumble of words kept flowing, the mantra and

the confessional, the constant details and grievances, the accusations. I knew my role in this. I was to answer for all women or fix his life.

This is not what I grew up to be, I thought. I did not grow up to be used or taken over. Resentment seethed under his skin as if it were a creature writhing to get out. I looked to the dark uncurtained windows, to the dark forest. To my forest.

Fir tree, your heart is red and strong. Hemlock, you bow and tip your feathered cap to me. Yew, bent and weedy, you are strong as sinew. Please help me.

I kept ducking his angular words. Sticks and stones, I thought, sticks and stones, the verse and rhythm a wall holding back the volley. Words will never hurt me, I thought, words will never hurt me.

And then I straightened up. Bullshit, I thought. Who is this guy? That verse is bullshit. Words are my life. Words stay in my mind, haunt me or buoy me. Kind words or harsh words. Kind ones of family and friends, or angry ones like these, the ones meant to do their ugly work.

I expect I looked calm, a book on my lap, my hand on my dog's head. But I was running the scenarios for the rest of this dark and isolated night.

What will he do with this anger if I stand up and walk out? Will he come after me? What about the kids?

My home is my home, Dad. I built this, just as you built the home we grew up in.

No one gets to drive me out.

Walk out? Why should I walk out? This is my house. I can't let this flow of words continue in my house. I look at

him, veins pulsing in him as he removes his clothes, words still sliding from his mouth like vomit, and challenge him. To make his words stop, I say the truth I most fear about him. The words that will most deflate him.

You'd like to hit me, wouldn't you? That's what you're trying to say, isn't it? Why don't you just hit me and get it over with?

What a sick thing to say, he said.

And then he climbed into bed, and we turned away from each other in silence.

DAD SAID *a polar bear circled their camp as they slept. Circled and circled. Its paw prints were everywhere in the morning.*

THESE MOMENTS come when you draw the line. Some voice inside says, That's enough, You've tried hard enough.

It's your mother's voice. Your father's voice. Your sisters' and brothers' and grandmother's. Your own. It says this has got to stop. No more bending, no more trying, no more kidding. You cannot fix a drunken misogynist.

I helped Connor into the car, drove the snowy road to town. Climbed the stairs up from the narrow doorway nestled between Wing's Grocery and Hipperson's Hardware on Baker Street, up to the counseling office. The room was bright with sunlight flooding in over Elephant Mountain and Kootenay Lake. The carpets were clean, the receptionist welcoming.

I looked around. Every person in the waiting room was a woman. I knew most of them, and most knew me. And I knew, because it was a small town, that on this morning,

each woman present was dealing with a man who was a drunk. The men weren't here. The women were.

Slowly, with the help of a counsellor, I became absolutely clear that I wanted this man out of my life. I set deadlines to push him out of my home. But he didn't really leave, because there were always requests, and each seemed reasonable. He had to come back for pots, another time for bedding. Could he come back for the kids' clothes next week? Couldn't we be friends, he asked each time, while telling me how much work it was to get his new place ready.

His continuing contact was not threatening but pleading, just enough to make me distrust my own perceptions. I wondered if my fears were groundless. Perhaps there was no violence there. Perhaps he was just another confused, harmless, clinging man.

He made unexpected visits when he was in the neighborhood, just so we could remain on speaking terms. At a dance at our community hall, he put his arm around me. I shrugged him off, walked away. Making a scene would seem way out of line. But the social niceties wore me down, and when I saw him standing on the side steps of the hall, looking at my house—or was he watching?—I grew wary.

That week I dreamt the doe in my forest was being gutted alive. In the dream, I woke to screaming, the scream only a deer can make when dogs rip her apart. I raced outside; there were headlights and the loud voices of men yelling encouragement, not to the dogs, but to each other for this ritual rape and murder. They were gutting her while she was alive. I was alone and there was nothing

I could do. It was too late for her. If they saw me, my turn would be next.

That was a dream. I did not know any such men. I did not know hunters who would behave in this fashion.

But every dream of violence is a warning.

HE MADE DRUNKEN phone calls in the middle of the night, always with some crisis to rebait the hook. The phrasing was so elliptical that I could not tell the true meaning of his words. One time it was clear there was a woman with him in his motel room and he wanted to make sure I knew she was there.

I found a sweet greeting card left in my unlocked car. He had placed it there in the night, outside my front door as I slept, the night before I left on a trip. It was a belated birthday wish to me, with greetings to my father, who I was going to meet in Nova Scotia. It was a card no one could take offense at; they would dismiss me as paranoid were they to read it, and as I look at it now, I wonder again if I am wrong. But at the time, during my attempts to make him leave, and his refusal to go, finding this card in my car in the morning nauseated me. The envelope included a tape by Patsy Cline, love songs that in this context were revolting. Again, I tried to push away the possible danger, rationalize his behavior as the last gasps of something that was over.

Each act could be analyzed and dismissed. But I did not kid myself. These inappropriate acts may have seemed to be only annoying exasperations, but they were warning signs that women know. He was telling me that he had access to

me, that he knew where I was and what I was doing and could stand outside my house in the night.

On the radio, I heard stories of women like me, who made a man leave but he wouldn't. How the contact continued, the invasion escalated, particularly when she declared her own territory, kicked him out or walked out herself. There were danger signs, someone on the radio always intones, if only she or someone had paid attention, if only she hadn't tried to exist on her own, if only another male—a brother or father—had protected her.

The police pay little attention to women's concerns here. Where we live there are so few police, anyway. If we demand it, they will put something on file for reference in case violence does eventually occur. It's an ugly stinking offer.

This man became every abusive man I had ever heard of or feared. He was the man who knew my ways, who knew when I was unguarded. He entered my nights, chased me down hallways and through walls. I flew above the streets, sought refuge in long-forgotten buildings.

He knew how like my father I was, how proud and stubborn and independent. How unlikely I was to ask for help. I was a feminist, and I found it impossible to admit that this was happening to me.

DAD SAID *they always took precautions. The dangers could be too great. Situations that were life threatening or dangerous they really tried to avoid. They were too far out in the bush to call on any kind of help.*

I SAT READING, Connor by my side on the couch, when he called. It was 10:40 PM, very late for a call in the country. Such late-night calls always cause alarm. He knew this and I knew he knew this.

He wanted to talk. Wanted to see me. He was polite, but the politeness alerted me more than slurring drunkenness.

I imagined him as I had seen him so many times during the election campaign, pencil in hand, planning. The paper in front of him lined, foolscap perhaps, or the margin of a phone book.

He paused, said he didn't understand why we couldn't be friends.

In the silence, I knew he was toying with his pencil. I could hear it scratching on paper.

I looked to the window of my front door, uncurtained to the night. I didn't know where he was calling from, knew he could appear at that dark window within minutes, plead once more with me to just sit down and listen to him. To hear again his list of grievances. The conversation would escalate from blame and contempt to anger. It was late. I was alone and I could not bear this anymore.

I knew what he was writing. He was writing my name.

I breathed deeply, and with all the power of my imagination, I removed the pencil from his hand. I broke it in two before he could write my name or erase me. I told him never to call me again.

I hung up. Looked to the window. Stood up.

Except with him, I have never felt sick fear in my home; the sudden night sounds of trees cracking, coyotes barking,

deer huffing and stamping on the deck no longer scare me. But this scare was dirty.

My gut said, Get the hell out of the house. Now.

I grabbed Connor by the collar and we ran for the car.

The next morning, Connor and I re-entered our abruptly abandoned living room. I walked in not to a room left behind in peace, a room that awaited my return, but to a room cold and violated by fear. When I found it necessary to step inside my own door with caution, I wanted to throw up. I wanted to open every window, scrub every surface.

I vowed I would never accommodate this kind of man again. I would never be taken in by such a man's stories, his leechlike attachments and needs. His insidious and colonizing anger.

I would not be inhabited. I would confront. I would antagonize when necessary. I would stake my claim and defend it.

No one ever will drive me from my home again.

I LEARNED that when I hung up, he called a friend of mine. Made accusations to him about me and my feminist friends, about neighbors, scornful angry ranting, with vows that he would "bring people down." This friend tried to defuse the anger but wanted to warn me.

I documented all contact. Took appropriate steps through the local Advocacy Centre, which hand-delivered a letter of warning to him. He was now aware that other people were watching.

Still, I am the one who crosses the street to avoid him in our small town. I am the one who still can't yell him down.

I should be done with this person. But I'm not.

I kicked this man out of my life years ago, and I'm a long way from home. The door here in my motel, my fort, is locked.

But still, it's hard to go to sleep at night. His hooks are in me still, and the old nightmares will come.

When I lived with Connor by my side, it was as if his very maleness gave me the right, the confidence, to walk through life. That always, this big gentle dog would protect me, in his loyalty and love, would turn fierce when the time came, and no one would try to get past him.

Now the leash in my hand is empty.

Here in my motel room in Fort Macleod, the challenge I pose for myself nicks at my brain, even as I don't wish to ask it. Do I have the guts to go it alone? To confront fear alone? Without a dog I love by my side? Without family or partner? Do I have the rock-bottom faith in my right to exist, to live and travel, a woman alone in the country, with no illusion of male protection?

Yes, my father's stories will bolster me. Their maleness and confidence will buoy me. But still, I will be, want to be, a woman alone.

\mathcal{W}hen Dad was home, his big gray packing crates with the rope handles sat empty. Sometimes, down in the basement when no one else was there, I would pull up the heavy hasp for the padlock, then lift the lid. I would stand looking at the small built-in trays, imagine filling them with forks or spoons or fish-gutting knives, microscopes or tin plates, or whatever I wanted to take with me. From deep within the crate's dark corners, the smell of tents and old canvas and adventure rose to meet me.

As kids, we paid little attention to the details of Dad's adventures. My main memory is of him coming home or of us traveling north to meet him.

Dad's home! one of my brothers or sisters would shout, and Dad and other men, strange travelers who had been in the bush a long time, would appear walking single file along the sidewalk beside our house. They all had beards. They all wore khaki. They would carry a canoe on their shoulders, sometimes bags of filleted fish, and always the plant samples, still wet, with long and stringy root systems, bagged in cellophane. Dinty would race out in welcome, then remember his duties and begin growling. Sometimes he would growl at Dad by mistake, then make up for it by dancing all over the place. My main memory of Dad's homecomings is laughter, the dog fawning over Dad's companions and then barking at Dad.

When he was home, Dad built us a canvas wading pool. He took photos and developed them. He made and repaired things at his workbench. I was the little awestruck girl who watched as he replicated the harness worn by northern dogs as they hauled sleds heavy laden with furs.

Although I was very young, the gray packing crates and Dad disappeared up north often enough for me to remember his absence.

Dad's adventures took us on our own trips north to meet him in Winnipeg, where we stayed with our grandparents. We traveled farther north, to Lac du Bonnet—such an exotic name on our young tongues. We drove on rainy dark roads at night, five kids in the car, Mum at the wheel and our trailer jackknifing and truck drivers stopping to help. Even as Dad was off having his adventures, we were living in our own world with our mother.

These are the stories we would ask Mum to repeat: how on the long drive to Lac du Bonnet, when the rainstorm grew terrible and dark, when the trailer caught and twisted, how truckers stopped in the night to help us. It is our dark-and-stormy-night story, that people will help each other, and we remember it well through the retelling. We grew up knowing that travel meant adventure. That there was a world out there worth exploring, that strangers were not to be feared.

*T*oday is a strong sunny morning, even though it's late November. I am driving out to Shirley Bruised Head's, after a visit to the Head-Smashed-In Buffalo Jump Interpretive Centre near Fort Macleod. Shirley's an educator and interpreter at the center, and she helped me once with some botanical identification. She's a writer, and we have visited several times over the years. I have told her I had to put Connor to sleep and that's why I'm holed up in Fort Macleod. She's invited me to her home for coffee.

On the phone Shirley says, Go past the Jump. Turn right at the tree. Her son in the background calls out: No, Mum, you can only turn left at the tree. She laughs, and I can hear him laughing too. The rest of the directions involve a gravel road and a coulee.

I like the singularity. Tree. Gravel road. Coulee.

In the car, my wet facecloth has turned to ice in its plastic bag. I stop at the bakery, pick up a fresh apple fritter and some treats for Shirley's house.

I listen over and over to "MacPherson's Lament" while driving through this brilliant day. A few years ago at a firehall in Cape Breton, I got to hear Rawlins Cross play this lament, which I had never heard before. I sat in a sea of strangers in the smoky dark hall, and when the lament began, I laid my head on my arms and wept my heart out, wept for everything I had ever loved and laughed for, everything I had ever mourned. That night I wasn't the only

one weeping. They had to play it again, as an encore, as if we could dance in its pure joy and sorrow.

The lament is perfect for this time and place, the great sweeping sadness of the music, and the lifting, too; like the prairie, this swelling of strength works within me. I understand why my father loved the prairie and the huge tundra. Outside the car, I see vast blocks of color, blue sky and wheat-straw blonde forever, expanses that open my lungs, slow my breathing. I lift my eyes with the rise of the prairie to the cliff of the jump site itself.

The day is cold, and there are few people at the buffalo jump. As I hike up from the parking lot, I am an adventurer, an observer, an explorer. Rebounding. Light of hip. Strong of eye. Noting the types of grasses, their undulation.

Connor was movement, his coat like long grasses, feathering in the wind. Movement. No movement.

At the interpretive center, which I've visited so many times, I stop in a corner, alone, bury my face in the forehead of the stuffed buffalo. Hello, baby, I say.

I take the stairs, then walk out on the cliff top. Above the jump, some visitors ahead of me linger, then leave. I'm alone. I'm ready now to do my howling, to throw my voice in with the wind's, where only the wind will hear me, will carry my cries out to join the rolling grasses, where I can see Connor running, can imagine him so clearly. But it's a funny thing, this grief. I thought this would be my big moment, where I could let go. But nothing comes. As if grief takes its own time and makes its own occasion.

Instead, I am happy to be alone, look through the viewfinder, identify the mountains way far away. This odd

refusal to let go at the expected time is the same as that moment at the vet's, when I was ready for the hardest moment to be his dying, but it wasn't.

Before I leave the interpretive center, I stand inside a circle of boulders, a circle of the four seasons, and I like the words that light up on one of them. "Summer is Home Days when we move down on the prairie." Ronald Four Horns, who works here, comes over and asks if I have an old man. He says I should come out of the mountains this summer, come down to the prairies and dance at the powwow, and then he asks again if I have an old man. I say a bit jokingly, and dammit, probably crying too, that the only old man I had I put to sleep a few days ago and that he wasn't my old man but was better than most.

And then Ronald says I'll like Shirley's place because there are lots of dogs there to greet me.

I make the correct turn: left at the tree.

SHIRLEY'S IS PAST a cattle guard, down a dusty road. It's a bare house, alone above the coulees. She told me that by daylight you would think it's out there all on its own. But at night, all around, you can see house lights twinkling.

I get there about noon. Seven dogs, at least, greet me. Some are excited and wiggling, sniffing the bag of doughnuts from the bakery. Some bark and bluff. Two hang back and watch me closely. I greet them each in the way they want to be greeted, ruffle the coats of some, chide others with an "Oh come now," and offer a respectful hello to the two who watch from a distance.

Shirley welcomes me at the door. I hand her the treats, and she says the kids will like them. Inside, the TV's turned on to figure skating—I'd been watching it earlier, too. I sink into a chair. Hey, kids, Shirley calls out to the back bedrooms, Lu Chen's on. I smile to myself. What did I think, Indians don't watch figure skating?

She introduces me to all her kids as they emerge from back rooms, her son and his wife, her adopted twins, and her three grandchildren, about diaper age, who crawl around in the living room. The older ones are getting ready to go to a birthday party, and I tell them there's doughnuts.

The curtains are drawn against the hot afternoon sun. Shirley pulls them back to show me a stunning vista of coulees, golden light, and the Oldman River far away. There's still no snow, even this late in November.

She closes the curtains again, and we watch and comment on the skaters—Did you see him fall, Wasn't she amazing?—that sort of thing—while the kids bustle around and the coffee perks. When the older ones have left the house, the car doors have slammed, and they're off to their party, and we're there with just the little kids, I ask Shirley to tell me their names again. Sunny Dawn is the girl, Tee and Riel the boys. Shirley says her family goes back to the Métis leader Gabriel Dumont, and there's usually a baby named Riel in each generation.

I tell Shirley that back home in British Columbia when the Doukhobors hold a commemoration, someone reads greetings from Russia from a member of the Tolstoy family, generations down from the Leo Tolstoy who helped the

Doukhobors escape to Canada. Shirley nods, then walks to the kitchen to pour coffee. Her hair's shorter than last time I saw her, and I call out, Shirley, you cut your hair! She says, Yes, it's a Blackfoot custom to cut your hair when you lose someone.

And then before she reaches for the coffee pot, she turns toward me.

My daughter was killed in a car crash.

Oh, no.

Two months ago on a road near here, she says.

Oh, Shirley.

In September. It was a sunny day.

She had just graduated from high school. It was a Saturday morning, September 27. The roads were clear and open. The man in the other car lived. My daughter died.

Oh Jesus, I think, and I came here crying over my dog? I tuck in my grief as if it were a stained shirt.

What is your daughter's name? I ask.

Leslie-Dawn, she says, turning back toward the coffee.

In that moment, for a moment, I am ashamed of my grief over Connor. She could so easily, so gently, or not so gently, have said on the phone, So what? Who cares about your damned dog? My daughter's dead. Go find something real to cry about. But she said, Come for coffee.

She turns to a shelf to find the photo albums. She shows me pictures of her dark-haired daughter—Leslie the basketball player, Leslie in her dress for the grad. She tells me how Leslie had held out, refused to find a dress until the last minute, when they drove the thirty miles to Lethbridge and blew a month of Shirley's wages on the best, the most

beautiful dress they could find. In the pictures, Leslie is young and strong and stunning. She is a basketball player, confident and beautiful and all dressed up, surrounded by friends.

Then Shirley hauls out an older album, points to the photo of Leslie and the cat she loved, tells me of their sadness at his death, how long and hard they mourned his loss.

Grief is grief, she says.

I walk out into the sunlight, past the dogs, and get my pictures of Connor from my car, pictures of our trips to Nova Scotia. I tell Shirley stories of our life together, our travels to so many parts of Canada and my recent dreams of him swimming wild rivers. I tell her my fear of being alone.

As the afternoon goes on, the phone rings, diapers need changing, more coffee gets made. She tells me about the phone call from the police after the accident, of her son's dreams before, dreams of men on horseback against the buttes, the men crying.

Shirley tells me how everything reverted to the easiest form after her daughter died. The grandson's toilet training forgotten, the bottle given again.

While the sunlight holds, we bundle up the kids against the cold for a walk to the Oldman River. We work side by side, stuffing the kids into snowsuits and boots, mittens and toques.

As we walk the steep path down to the river flats, I feel familiar and safe in the presence of the dogs and the coulees. A long time ago I lived near this river, and over the years have lived near others like it, in similar coulees, with the same light and the old bleached silver-gray cottonwoods to

perch on. I feel comforted by this river, by walking among these twisted silver trees.

The dogs run wild through the river flats and the brambles, their bodies young and supple, knocking each other over in their headlong gallop, ass over teakettle and up and racing again.

They're chasing lions, the kids say, and swing sticks to fight the lions off, get tumbled instead by the madly scrambling dogs. In the moments of silence, we hear coyotes yipping and singing, in counterpoint to the dogs.

As each dog races by, circling us in huge loops that keep us at their center, Shirley tells me their stories. The two who hung back when I arrived remain outside the scramble. They take turns walking singly or in perfect unison behind Shirley. They're Leslie's dogs, she tells me, red heelers named Clover and Sugar.

We walk side by side. We talk sometimes, absorbed in the light, the kids and the dogs, the river and the silver bones of cottonwood. She is seeing Leslie here. I am seeing Connor.

Sometimes Riel or Tee takes my hand, and it is sweet and lovely to be accepted and comforted by a child.

Then Tee lets go of me, swings his stick at bushes with a few dried-up berries. *Arctostaphylos uva-ursi*, I think, saying the word over and over in my head. What a beautiful language my father knows.

Shirley points out where the old Indian Agency building stood, where people came for sugar and flour, rations to keep them from starving. And somewhere in the flat space, where bushes now grow, there was a school.

A long-legged blonde dog appears and joins the others. Lucky, a Peigan Purebred, Shirley laughs, and I tell her about all the black dogs in my valley, Slocan Valley Variegated Black Dog, a neighbor calls them.

Lucky fords the river, which is forming crusts of ice. There's a sound of giant thuds, like boulders being thrown in. Beaver tails slapping a warning, Shirley tells me. Lucky pushes through the ice to the far side, shakes ice shards and water from his coat, looks from across the river at us for our approval.

The light is pink and silver on the river, gold on the coulees, and back on the lip of the hill where we came from, a tree is bathed in golden light. It is bent from years in the wind, like the wind-trained tree in the picture back in my motel room.

I am learning my father's vocabulary—wind-trained tree, *Arctostaphylos uva-ursi*, *Epilobium angustifolium*— such lovely acrobatic words.

Shirley carries Sunny Dawn, by now a chunky pink sleeping bundle, and the boys are happy again to hold my hands. We're worn out, hungry, and cold, and it's a long way back up the coulee. We make it to the road; then Shirley waits with the kids and dogs while I scramble up the long hill to get the car. I slide into my little Toyota, plow up and over a rise onto the back road, laughing at the unexpectedly heavy traffic and swirl of dust out here at this moment. Watching from below, Shirley wonders if I'll get lost. In a city I would, but not here. I hunch to the wheel, sight through the dust, make the right moves.

Later, when we say good-bye, she says, Wait, I have something for you, and she gives me a clay buffalo. It's a strange creature, almost two-dimensional it is so flat, yet with its head turned sideways to look at the viewer, like a curious cow. Its body is glazed with iridescent blues and greens. A surrealistic buffalo, she says, and bids me a safe drive. I drive back in the night, see the lights of houses twinkling through the coulees.

OUR ACCIDENT will come later, on a small plane in the woods of northern Minnesota.

Rita, Rita, pick up the phone. It's Mum. It's an emergency. There's been an accident.

AT THE MOTEL, I set the buffalo near Dad's maps, next to my picture of Connor. Strange icons, I think, and turn on the tape machine. The day has been long and bittersweet and emotional. I want my father's voice, his satisfactory endings, to carry me into sleep.

The whole coast of the Hudson Bay was a marine basin with a gentle slope, three feet to the mile, and characterized by a six-foot tide, Dad says.

At low tide up to two miles of marine clay was exposed when the water was out. This particular year the ice hadn't left the bay completely. In early July, the ice floes were pretty much up the beaches, so we had to travel at high tide and in the crevasses of the floe ice. It wasn't particularly hazardous, but your travel was geared to being in the water at high tide and out of the water before the tide went out.

It was not quite full daylight around the clock; it was dusk from 11:30 to 1:00 *AM* but light enough to travel. On one occasion late at night a strong offshore wind sent the tide out early and we found we were stranded two miles from shore on the marine clays, with no water, and surrounded by ice floes.

It's unpredictable with an offshore wind when the tide will come back, but we expected it would be a few hours. We took what was necessary and walked up to our ankles through marine clay. It was a cold night—the tenth of July—and frost formed on our clothing.

With a good fire, we warmed up and cooked. Our canoes were beached two miles out. After some hours we went back— took dry driftwood and got a good fire going out there on the lake bed to stay warm. Gradually we were afloat again, but with the tide and offshore wind came a heavy fog. We couldn't see the front of the canoe from the stern. The only safe thing to do was head in to the beach again, set up camp, and wait.

AND SO, with Dad safely camped, I too go to sleep.

\mathcal{T}he next morning, I make a quick foray from my motel room. Get out into the wind, gear up for the day.

I have found a different kind of yogurt at the store across the way. Creamy and thick with fruit on the bottom. None of that pale low-fat stuff for me now. No, thanks. I lean my way across the street against the wind and buy several containers for my small fridge. Walk downtown and look at some boots like the kind Shirley and everyone here seems to wear. Stylish and tough leather boots that lace up, with a small fringe of leather at the toe. I look up from the display of boots to a rack of gift bags. There is Connor. Dog face on a gift bag. Big black head and silky hair, looking at me.

I buy him in three sizes.

Down a side street, a tumbleweed thrashes around, caught on a fence, tangled with some black garbage bags. I release it, just to see it tumble. Tumbleweed. *Amaranthus albus.*

Back at my room, I pick up one of the books I brought along. Open some yogurt and settle myself comfortably in a small stuffed chair, feet on the bed, glance up at the painting of the wind-trained tree, and start in on my pile of odd finds.

I've taken to looking for old books that guide me into the nooks and crannies of the country—into the bush or into the kitchen—old editions from the Queen's Printer, small

pamphlets like "Fur Bearing Animals, (Reprinted from *The Beaver,* Hudson's Bay Company, 1959.)" Spiral-bound cookbooks produced by ladies' auxiliaries across the country or special editions from specific areas with long titles, like the *North East Saskatchewan Wild Fruit Development Association's Wild Fruit Recipes.* From the north, the *Northern Cookbook,* which includes pemmican and bannock. I have pamphlets on cooking with sauerkraut and a whole book from 1956 on baking with sour cream and have turned out a calorie-laden wondrous strawberry pie made with sour cream, pecan pie made with sour cream, everything made with sour cream.

Some of these books are so musty that I wear a carpenter's sanding mask as I read them. But I am keen for these hidden veins of culture, imagine the writers and the cooks, the trappers and the explorers, dieticians in their lab coats and fruit pickers on their ladders, all at their work.

Last time, from deep within the sloping piles I always find myself straightening at the used bookstore back home, I pulled a small beige booklet, "It's in the Wind" by R.A. Hornstein. It had a heavy textured cover like a leathery old hand you want to touch, like the feel of dried and cracking earth.

The cover was an orange woodcut illustration of a tornado touching down on farmland. I opened it with excitement, as if I were Dorothy picked up by the tornado itself. I was tumbled back to my childhood, not only where tornadoes swirled, but where we gouged the same kind of woodcuts. I've brought this book with me and open it once more with delight.

Here are sunspots and waterspouts, rainbows and hurricanes.

Each chapter begins with art and a line of poetry about the weather, then goes on to explain the detailed science of the phenomenon.

The chapter on tornadoes leads with a quote from Job: "Out of the south cometh the whirlwind."

I flip back to the frontispiece: it's a Canadian publication, by the Meteorologist-in-Charge of the Dominion Public Weather Office in Halifax, Nova Scotia. It was published in 1960, the same vintage as my father's work. I like it for everything: the language alone delights me. Mouth teasers like *meteorologist* and mellifluous nouns like *Dominion*. Words that make my tongue skip and twist, words that tempt my palate.

It says tornadoes, the kind of violent and exciting weather we grew up in, are created when two massive fronts—one heavy and cold from the west, one warm and moist from the south—collide. When the cold, heavy air from the west moves fast enough, it overrides the lighter southern air. The heavier air can't stay on top, overbalancing the light, and the two masses begin to shove and twist in their battle to change positions. This massive and powerful imbalance where the turbulence starts is called the windshift line.

The heavy air from the west: I look down at the desktop map. In the west, I place my left hand palm down; in the south, my right hand, also palm down. I move them toward each other until they collide and the left crosses over, sits astride the right. The left presses down and the right, the

lighter air, begins to struggle, to push and fight to come out on top. It shoves at the inner edge of the upper hand, then slips up from beneath and rolls the left hand over. The right hand comes out on top. The windshift line. Opposing forces. Turmoil, struggle, and change.

AS CHILDREN, we watched the tornadoes coming, knew exactly what to do. We relished them even, as if the world would toss chaos at the flat and dependable prairie landscape, testing our ability to survive and adapt. We knew where to run in the basement, down to the furnace room, by the gray packing cases, in the house our father built, safe inside as our world outside was torn apart.

DAD'S OUTSIDE, *pounding at the door. The wind is howling. Trees are crashing. My girlfriend and I, home alone when the storm strikes, hear Dad's call through the roar of the winds, race up from the basement, and with Dad shoving, and us pulling, we haul open the door against the suction and he tumbles in.*

This picture stays with me, of danger, of our own power, of safety in our home. We always knew that after the tornado, we would emerge to survey the wreckage, the wonder, knew that our world would be changed. We would repair what we could, but some major landmark would be gone forever.

I WALK THROUGH Fort Macleod. Above the theater, out over the prairie, the weather is shifting—Chinook arches, dramatic arcs of dark cloud, meet and collide, fight for dominion

before my eyes. I stand on the street and stare at the sky. It's as if earth and sky are trying to illustrate the power of the windshift before my eyes.

I understand that I am in turbulence. I don't know if I can weather living alone in the country, a single woman, balancing my life and trusting my judgment.

I love the engagement of art and science in the booklet, the woodcut, the poetry, the rich scientific language. I love how the windshift image spells the struggle of opposing forces. The windshift can stand for death and life or fear and laughter. It's the struggle between hard work and taking the time for pure pleasure, even romance, and what happens when love turns ugly.

This image of turbulence and change shakes me. But it excites me, too.

I can be crushed, or I can work and work, twist and swirl, and come out on top.

*A*s I listen to my father's tapes late into the cold night, it is fitting that winter winds, howling and screaming at sixty miles an hour, smash at the walls of my room.

The wind shoves me, lashes round me, as if charging me with purpose. Some days the wind is gentle. It teases me when others can't. The wind restores my sense of humor with its own, blasts me so hard it makes me skip, grabs my hat like a dog snatching a sandwich, makes me chase after it, like a kid playing tag.

I hope to find equilibrium and lightness after the turbulence.

There are well-worn cures for upset and loneliness, geographic cures and romantic cures. Just a few months ago, here in Fort Macleod, I thought I had found my romantic cure. I fell in love in a second—a sweet summer crush, the kind that ends chastely, with longing. The kind you can never regret.

In the summer heat, I headed out from B.C. to meet my family in Manitoba. I felt bad about leaving Connor behind, but the hot spell would have been too hard on him, so he stayed with my neighbor.

I picked up a brochure advertising summer stock theater, and booked my evening's ticket from the road. I sailed through the Crowsnest, turned onto the broad street of Fort Macleod, threw my suitcases into the first room offered at

the Fort Motel, flipped on the air-conditioning, sprinted downtown in the warm evening, and sank into the red seats and cool darkness of the old Empress Theatre. High above, on the pressed-tin ceiling, were three neon tulips. Huge flowers in pink and purple and red neon, an anniversary gift made decades earlier by the theater owner to his wife.

I felt the glory, the initial relief of being a traveler, ready for entertainment and someone else's stories. The theater filled up enough to feel right; people were in a good mood, greeting old friends, laughing and chatting, ready for the play: *Saturday Night,* a small-town romance mixing moonlight with misadventure.

I was astonished by the range and talent of the players, such an unexpected gift for my first day on the road. The singing was good, the piano rollicking, and the dancing and romancing wonderful. I let myself go, relaxed into the hands of competent storytellers and into the fantasy of small-town life full of love and laughter and outrageous turns of fortune. For a few hours, I lived there.

Over and over, I found myself laughing and clapping. In one scene, the women performed the role of well-oiled pistons. They swirled and twirled in perfect rhythm, slapped hands, slipped limbs together and apart and around each other, while the men, the machine operators, sang, "That's the sound of the man, working on the chain gang." Every step was perfect, every note, every harmony, true to pitch.

I felt myself loosening, breathing easily and deeply, a stranger caressed by the beauty of all those voices, then later,

one man's voice, then a man and a woman together, singing "Blue Bayou" and "Hear That Lonesome Whippoorwill." The words about being so lonesome you could cry and how the leaves begin to die were so beautiful that you could croon them in absolute certainty that neither loneliness nor death were allowed into the room.

I let go into harmonies, stories already shaped, songs so familiar I could sing along in my head. Who were these singers? Who was the man with such a voice? I squinted at my program in the dark of the theater. Anthony Steel. From Calgary.

He had a shock of blonde hair like wheat grass, and in the midst of the music and laughter, I was sure that if I were ten years younger I would fall in love with him.

I WALKED DOWN the long wide main street to the bakery, ordered a fresh fritter and hot coffee and wrote my post-cards—pictures of buffalo and the RCMP, the long railway bridge at Lethbridge, pictures of Blackfoot people. I had a whole day to enjoy, and there were more shows to see, including a matinee with last night's cast in a different play.

I walked along the edge of the prairie and then toward the fort, the rebuilt outpost of the Mounties. In the sunlight I caught the swirl of horses as eight young people, in the red serge of the RCMP, rode into the square. The riders bore lances, and the horses each had a maple leaf shaved smartly onto their left haunches. As they leapt forward, I ran to the bleachers with a few other tourists to watch these young-sters performing the RCMP musical ride. They formed two

lines; the lines of horses met, passed through and turned and formed the shape of an *X*, then a *Y*. Sitting in the sun, watching the riders gain skill and confidence in their performance, I was a happy tourist.

I love watching people at their work, to see how they take their learning, their setbacks or leaps forward, even to see them crawling through the inevitable doldrums and coming out the other side. I draw courage from them when I am tired or crawling myself. I pay special attention to the girls, happy to know there are clubs and groups where girls develop their own competence and confidence, because it's that confidence that will get them through the rough times.

In 4-H, in our girlhood, we prepared and practiced without the competitive overpowering presence of boys; we learned to use our heads. We learned about voice—not just physical voice, but presence, the ability to stand up and deliver, to take risks—even if it was a demonstration, in a small-town school, of how to make sloppy joes. Carloads of girls, we traveled with our mothers to small towns and did our demonstrations, standing before the judges; we chopped our vegetables, talked, laughed, overcame fear, shyness, and embarrassment. We took the risks and had the ribbons to show for it later.

As I watched these girls on their horses, I wondered at our ability to lose our confidence, our voice. At how, with the man I once lived with, I lost my confidence, my voice. How we let someone in until eventually, in our generosity, or in our brainwashed belief that men are smarter than women, we do think they're better, a better talker, or smarter, with a better plan, until it will almost kill us.

These girls sat tall and straight. Deep in our guts, we carry a ferocity that helps us reclaim ourselves, a belief in ourselves that we learned as girls. We can still call on the 4 HS—our head, heart, hands, and health—to expel the fear, to reclaim our territory. And set out with hope again.

My home is my hard-fought territory. I have gone away and come back. I have hated it and loved it, but it's where I have learned who I am. It's where, within those mountains, I have carved out light. And I will not cede it again.

Outside the fence, a group of young Hutterite girls, eleven or thirteen years old, all dressed in blues and greens, ran up the sidewalk, then settled on the grass outside the ring. The horses thundered past, hooves throwing up clods of earth, and the girls, like a small flock of birds in unison, rose to whisk the dirt from their dresses, their hands like small wings, then settled again to watch the ride, as behind them more cars and vans slowed to do the same.

I WALKED FROM the musical ride over to the theater and waited with a few other people under the awning for the doors to open. The actor—Anthony—the singer with the blonde hair, was there, too. We talked for a minute, pleasantries about the play last night. I told him how happy it made me, harmonies that really worked.

He asked if I were traveling and where I lived and where I was headed. He didn't live in Fort Macleod either but was down from Calgary. We stood like prairie people do together, looking out at the sky, talking about the perfect weather, hot and bright in the day, with a breeze to cool you in the long light of evening.

I would have been happy to stand that way beside him for hours. But the box office opened, I bought my ticket for the matinee, then jaywalked across the wide empty street to the Bargain Store to look for a watch.

Later, just eight people, including me, sat scattered through the theater watching a play about Charles Dickens's bungling son, who lived at the fort. I was happy with myself, snuggled down in the theater seat. It was deeply satisfying to feel so much part of this world and its history. I understood the appearance of Col. Macleod and Jerry Potts, the native negotiator, Riel, and Sitting Bull, the jabs at Yankee violence and Custer's stupidity. Because I had read and understood its stories, knew they were part of our common wealth, I knew that I could come to this place in Canada or go anywhere in my country; because I cared about our stories or wanted to learn them, I had some right to belong.

The actors stood in the lobby to thank us for attending. Anthony asked if I would come to the evening play again and if I knew about the movie that was showing later. I didn't know if he was just being courteous to a stranger or if he was actually asking for my company. It was so long since I had been asked out that I couldn't tell.

Then the musical director said hello to me, and someone else approached Anthony. I remarked to the director that the Empress in Fort Macleod and the Capitol in Nelson could be sister theaters. Nelson? he said, and we jumped into the small-world-isn't-it game. His rock band played there long ago: Okay, what band? I asked, and when he said Frank Slide, I felt like I was Alice and had slipped right into the

rabbit hole. I shared a house with members of his band twenty-five years ago in Lethbridge. A band called Frank Slide, named for the deadly collapse of a mountainside in the Crowsnest Pass. A great name for a group: "Frank Slide, a thousand tons of heavy rock." We caught up on gossip and lives from two decades ago and parted laughing. I was an adventurer in a place where I recognized some landmarks.

Anthony sprinted after me. There you are, he said, and asked if I had a discount coupon for that night's play. Yes, I did, I said, and thanked him, and then he didn't know what to say, and I didn't say what I wanted to say, that maybe we could spend the afternoon together.

He headed into the box office, and I crossed the street to the Bargain Store so they could show me how to set the time on the watch I'd bought earlier for four dollars.

I was searching for the clerk back among the smell of cheap rubber sandals and hand towels when what I wanted to do was go take Anthony's hand and walk with him, wanted the world from the play to step from the stage and be my world for a little while. I wanted to be young again, to shake off what was left of the dark mountains in me—to talk and laugh and sing.

The day was stunning, wide open skies, a breeze, a day for a long walk by the river, a day to open up to the prairie. If I don't go now, I thought, I won't find him. I won't know where to look for him. Still, I felt shy, as if this were where my judgment of men could go all wrong. I wasn't ready for this kind of risk; this feeling of lightness and attraction was ludicrous.

The belittling and contradictory voices began their noise, and though they were my own voices in my own head, I was somewhere outside their debate. They were my panel of judges at *Reach for the Top*, and in moments like these, they watched my every move, glared at my indecision, blared their buzzer when I was wrong.

He's younger than you, said one. Can you imagine how you'll feel when he says no, he doesn't want to go for a walk with you?

I'll feel like shit, I thought, and looked down at my stupid four-dollar watch. So this is life, then, being safe, buying a watch in the Bargain Store, being too timid to risk rejection in Fort Macleod, Alberta.

Another voice, the confident wonderful one, rose from her chair and demanded that I look at her. Can you imagine how you'll feel if you waste this day? If, when you are old, what you recall of this day is how you stood at the back of the Bargain Store inhaling the fumes of cheap rubber sandals when you could have walked through the scent of cottonwood in the coulees? Is there something wrong with you? It was as if I were hearing my mother's voice, telling me to get outside and play in the sun.

I sprinted to the front of the store, walked across the wide, empty prairie street, slowly, quickly. And Anthony was there, in the theater office, writing a letter on yellow foolscap: "Dear Margaret" I read upside down, an old reporter's skill.

What are you doing this afternoon besides writing a letter? I asked.

Nothing, he said.

Do you want to go for a walk?

Yes, he said. The letter's to my sister.

And I thought to myself, All right!

WE WALKED THROUGH town. We walked along the Old-man River, then across the bridge and way down to the flats by the river, with town kids on bicycles as our attendants.

In the scent of the cottonwood, walking these mudflats so like the ones I walked as a child, we talked about our families, our lives and work and friendships, about where we lived, what our houses were like, the hours we kept, about housecleaning, about music.

I told him about Connor, that Connor would have loved this walk, would have loved this wind, and how it would lift the feathers on his legs. I told him how Connor's hips gave out and how often I had to lift him. That I dreaded the day I would have to put him to sleep.

We talked about theater and writing and acting and singing. Why we each do what we do.

I tried to identify wolf willow, different types of berries, the smell of the balm of Gilead. I told Anthony the time my botanist father went gathering wild herbs and stuffed a turkey using sage so bitter we had to scoop out the stuffing and throw it away.

We each lived far from our families. We each lived alone.

His family was very large, eighteen in all, Catholic. His father, who had died, was born in Wales. Margaret, the sister he was writing to, encouraged him in his acting and singing. He told me how always, his big sister, when he thought he no longer could, encouraged him to keep going.

We didn't hold hands; we just walked side by side.

We walked to the family-run drive-in at the east end of town, where the sunrise was so beautiful each morning. We ate burgers and chips at a picnic table, throwing scraps to the screeching gulls and laughing at them, trying to guess who was who in their hierarchy.

At the end of our afternoon, he put his arms around me, and we stood for a moment like that outside in the wind. Like you do. Like when you've found a person you're so unexpectedly happy with, when you're ready to fall in love.

It was as if for a moment I could live in the play itself, as if this Saturday night in Fort Macleod, Alberta, I could believe in romance. As if Anthony and I could kiss each other and sing, in unexpected, lovely harmony, hold hands, slip our limbs together, and turn and turn in perfect rhythm.

In this moment of sweetness we could walk into the sunset, get married beneath the neon tulips and pressed-tin ceiling of the old theater, go forth to make a family.

SO. SO. THAT SUMMER night I went back to the play. I wanted to hear him sing.

Yes, of course it was the happiness of seeing Anthony that propelled me, but it was the pleasure, too, of the theater itself. For hours at a time for everything to be right. To sink again into the plush seats, with the certainty of happiness, because the writers and performers and director had taken the time and the effort to tell a story, to open the door to imagination and music and the lightening of hearts.

After the play, the cast, as they did after each performance, greeted us before we stepped out onto Main Street,

still twilight in the long prairie light of August. Anthony came to meet me, and together we re-entered to watch the movie.

Contact is the story of two cultures meeting, cultures alien to each other, from different worlds, but taking the risk of trying to communicate. In comparison, it seemed the risk I contemplated wasn't so large. And so, I put my hand in Anthony's. He accepted my hand, but now looking back, I don't think he really held it.

The movie let out, and we drove down the street in his old blue Chev Impala. We drank coffee at a restaurant, where we talked endlessly, easily. We closed the restaurant down at 2:00 AM, then drove to my motel.

He turned off the engine and the lights, and I slid across the seat and put my arms around him and kissed him. He hesitated, and when I asked him if he'd like to take this any further, he hesitated again, and the moment stretched, and why didn't I know, why didn't I know, when he told me that he hadn't been with a woman in a long time. And I still didn't know; I said I hadn't been with a man, and then Anthony, I can say this now, bless his heart, he took my hand from where I touched his face, and he told me what he was really trying to tell me, that he was gay.

I can thank him now for holding up his hand to stop this. I can go back in that moment and thank him—for what he did then and for what he's done since—thank him for being a genuine and kind person.

I'm sorry, he said. And I said it, too.

Not because he was gay, but because we each together had lived for a few hours outside our own lives, had lived for

a few hours together in the same play. But it wasn't, couldn't be, our reality.

For these few hours, we had been a man and a woman who might fall in love. We had reached the moment of adjustment in our play, where the actors have reached a turning point, where in that split second, truth mattered more, a moment where decisions are made, in the long line of deciding who you really are.

Each of us turned a corner; each of us lost something and gained something.

In that car in the dark, we shed some romantic illusions. I have learned this since, and the lesson hasn't been simple. He put aside his last illusions of meeting a woman he might have children with, a deep, deep loss. For me, I set aside my hope for a man who would hold me in his arms, my deep wish for romance and love.

Anthony and I were at our windshift line. We just didn't know it then.

In that moment I felt so foolish, so damned hurt and stupid and angry. I drew back to my place on the far side of the car. And then we each sat looking at the windshield, and then again at each other, two people who cared for each other, and tried to keep talking, to extricate ourselves from this mess without saying anything mean, somehow trying to be kind, because the day itself had been such a kindness. But still, I walked into my room alone, stunned, stupefied. Embarrassed. Bereft. Astonished at my own willingness to misread the situation, or at his, or at his willingness to lead me there, or at myself for letting myself go so far, to take such an emotional risk and lose.

I was angry in that bewildered way where you shake your head, try to laugh at yourself, scorn yourself and your needs, and shake your head again, and then turn on the TV and then turn it off, and sit down and take off your shoes. And breathe deeply, in through the nose, out through the mouth, get back control. And then, when you're trying not to feel so hurt and lonely, and you're blowing your nose one last time and standing at the sink splashing your face, bracing yourself with cold, saying, That's enough now, you sneak just a glance in the mirror to see how well you're bearing up under the weight of tragedy and realize that you're sort of admiring how blue your bleary, bloodshot eyes are, and you know down deep that if you're admiring your own eyeballs, you can't be that upset. And then your dad's voice in your head teases you, saying, Don't smile now, or your face will crack, and then you can't help it, you grin at your reflection and know you're gonna be okay.

Sometimes I simply push through my father's work, transcribing but not understanding. Simply doing it because it's the task I have set for myself. Just keep going—that's all that matters. Just keep trying.

And even as I wade through the detail of his academic life, not caring about what committee he sat on, or where, or the personalities of those he worked with, even my petty irritation is a relief from my sorrow.

And just when I am grinding my teeth in boredom, he will delight me with some image that lifts me, that lifts his voice from the tape. Then he is no longer my frail and failing father but strong enough to pick me up, take me with him again, give me the image I need to see me through. He tells me about the Hudson Bay posts and native villages he and his co-workers stopped in. How on their journey they were welcomed by people who rarely had visitors. He speaks of patches of morel mushrooms found in a burn, of the polar bear circling camp, of pitching in at a village, unloading the supply boats, carrying the flour on his shoulders, knowing there'd be a slug of rum later for their efforts.

Sometimes I smile at the bravado of these stories, wonder if they're even true. But if he is doing it to delight me, or to re-create himself, I don't care, am only grateful for them, for their easy male confidence, their reassurance that all will be well if only you believe in yourself and your friends. I want his confidence to infuse me.

They are on a lake in northern Ontario. There are no waves for their floatplane to taxi off from. They must have waves to bump over, to get airborne. If you don't have waves, says Dad, you have to make them. The pilot, in the water's dead calm, his plane seriously overburdened with explorers and cargo, makes circles fast and tight, creates waves, heads the plane into them, and bump, bump, they get their lift.

"Stepping up on the waves," Dad calls this, and I like the image. How you get moving, work your way out of deadness.

Another scene he recalls with self-deprecating humor, where you just know that things are going to be hard for a minute but then work out all right.

After a day studying cormorants on a northern Manitoba lake, a day mired in cormorant shit on an inhospitable reef, Dad and his co-worker battle their way home through an un-expected storm. Soaked and cold, in their small boat, they fight waves three feet high. Battered with water and wind, Dad is at the stern, his friend at the bow. They steal glances at each other, break into big grins, big thumbs up, when, in truth, they are both badly frightened. Later, dry and safe in a restaurant, eating hot food, they in turn confide their fear.

"Our confidence in each other, even a false confidence, and having each other to admit it to, got us through," he tells me. And then the tape machine clicks off.

I sit alone, in my room, listening to his stories, without my confidante. Completely, singularly, utterly alone, seeking the confidence to get me through. Through fear, through the dead calm and stormy waters, through all the hackneyed metaphors.

IN THE FAMILY ALBUM there is a photo that strikes my heart with its loneliness and grace. The photo is black and white and grainy. Dad thinks he took it.

Three wolves, the leader with its head thrown up in a howl, race over crusted snow at the heels of a moose. The moose, carrying its large rack of antlers, crashes through small alder as if it will save him. The image repeats and repeats in my mind, grainy snow, gray animals.

LIVES OPEN UP. Lives close down. Dad's life, even in the telling of these stories, is preparing to shut down. Mine will again expand, though for these moments I confine myself to this small room to hear his stories of the big world, these stories of youth as I mourn the death of my dog and prepare for deaths that inevitably will come.

When I walk outside, contemplate the vastness of the prairie, I know that my father's own world is narrowing to his chair, the garden by the lake, these stories he has prepared.

My father would ask, most days: So, young lady, what have you done today to justify your existence? A very Scottish Presbyterian sort of question, I now understand. Some people find this question appalling, but I think it's a damned good one. And I know it's a question he often asked himself.

Once, when he was very sick, after he'd been through heart surgery, after he'd been through cancer, when he was summing up his life, he told me he thought he had been a failure. That he had never done enough or been enough.

He quoted from "The Builders," a poem he had memorized as a teenager. He couldn't remember the poet's name,

but he remembered the words. Dad called back those lines by Henry Wadsworth Longfellow that he'd put to memory half a century before.

> All are architects of Fate,
> Working in these walls of time;
> Some with massive deeds and great,
> Some with ornaments of rhyme.

Dad struggled to recall the next verse, but he closed his eyes and recited.

> Nothing useless is, or low;
> Each thing in its place is best:
> And what seems but idle show
> Strengthens and supports the rest.

It was such a private moment between us, upstairs in my parents' bedroom, where he sat in his housecoat. The pain I felt for him, even this unusual confessional mood itself, was almost unbearably intimate.

He gathered himself again. The tree-ring analysis, the staining and thin sectioning, the deep boring for pollen and the stories the pollen told us—those were my walls of time, Dad said. The scattering of records, the what and where and names of those northern plants, they were my ornaments of rhyme. That was my project, my record of life.

In that moment, I felt a shift begin in me. I was the child of my father. I was also an adult and it was my turn to take care of him, to help him believe in himself.

Dad, I know you want me to tell your stories. I know you want me to take away the fear you have of dying and leaving no record behind. I don't know if I can do this with you, Dad. You're so hard sometimes. You're so stubborn and overbearing. You know what will happen, Dad. You will have to give over your stories and then you'll have to trust me with them. Maybe I'll fail. Maybe they'll be boring. Maybe my interpretation will disappoint you. Perhaps it will take too long and you'll never see this work. This would be a big risk for us, Dad.

I began paying more attention, as if in my listening I could cure his sorrow. He was offering me the responsibility of his story. I could neither bear the weight of his sorrow nor leave it behind, as if it were both the burden and the cure for the sorrows I myself would face. The clues he gave me were mine to fashion to my will.

I SETTLE IN AGAIN with the tapes as he explains logistics and arrangements, how he got funding from the National Science Foundation and the Arctic Institute of North America, how what he liked most was the planning. He is so precise with detail that I want to shriek. He always wants me to understand the setup when I want to hear the stories.

As I listen, it's almost as if we're having a conversation or the replay of a conversation where he says, Well, Rita, that's how it was. Images of home, Dad, the basement, my own habits, all play in my mind as I listen.

Despite my impatience with the dry recitation of his plans, of lists made and items forgotten, I can't help seeing now the similarity of my own daily lists, items crossed off,

grocery lists, packing lists, even the list for this trip: Connor's photo, wet facecloth, plastic bag to hold it.

As he speaks, I cast aside my preconceived notions, my movie version of his confrontations with wild animals, of my father and his companions staggering haggard and bearded and lost through swamp and mosquitoes yet surviving half starved and half crazed.

Now, I understand, I have returned to the gray packing crates. From lists and plans and supplies, adventures will emerge like the promises held within the smell of old canvas, from the waiting trays filled with microscopes and the specimens of plants.

I asked him specifically about adventures. He said that adventures were something they tried to avoid; adventures could mean the loss of treasured personnel, of costly equipment. And that they were hundreds of miles from help.

He recalled a trainee from the Fish and Game Branch who showed up on their departure date with a huge accordion. This naïve young man, says Dad, had visions of sitting around the campfire at night playing his accordion. But it wasn't really the type of thing you can take along in a tightly packed canoe, he informed me. And I felt a bit of irritation with my father, or kind of bad for the kid. Of course he would want to sit by a campfire and play his accordion. I could see myself with the same hopeful notions, even if I knew it would be safer and more sensible to take a harmonica.

They had to be very cautious on the water, Dad said in answer to my skeptical look. And if there were ever a question of the rapids looking too fast, they unloaded the canoes

and portaged. They were out for two months at a time in a remote area. They were 250 miles from their base at Big Trout Lake and completely out of touch.

Then it finally dawned on me what he was trying to tell me. That this was how he worked. Methodically, very carefully, respecting detail. That the work was minute and the dangers, if not respected, could be huge. That he wasn't a *coureur de bois* or a romantic. He was a botanist on an expedition to collect plant specimens. And that nature didn't care who you were or what you were up to: you had to plan carefully and minimize the chance of costly errors. You don't carry an accordion on a canoe trip.

Alone, in this motel room, thousands of miles from him, I feel less and less alone. Instead, I relish the solitude and the time to concentrate. It gives me the focus and distance to understand both the terrain and my father more intimately.

I understand that his world is composed of specific details, that they keep him alive, the examination and the telling. That this is how he creates his pictures of life, not through sweeping generalization but through the accumulations. And that in the telling he will sometimes step back and let them all form a bigger picture.

When I really listen to him, I find I like to hear these stories. They are more protein and complex starch than sugar. They require my own digestion. I can almost hear my parents saying, Eat your porridge.

I DON'T THINK my father would ever have thought this out, but I think he was doing more than exploring. I think he

controlled his emotions by his adventuring, by entering other people's lives and territories. I don't think it's a bad thing to do.

It's my own method. I go to other people's lives, flee my own when I'm too confused or too hurt—my Canadian equivalent of joining the Foreign Legion. I've fled to Prince Rupert and Vancouver, Edmonton and Sudbury, Freeport and Fort Macleod, all to leave my life behind, find work and solace in the stories of other people, to find new images to carry me forward. I have immersed myself for a time in their lives and geography, stories and struggles, to escape mine or to put them into a larger perspective.

I finally understand that in this room my father's precise details, his stories of far away, are providing the distance I need to ground me. I get up and leave the room. Walk down the alley I once walked with Connor at my side. Down past the old Chinese laundry, past a rusted-out truck, out to where I saw kids riding horseback last summer at the fort.

Here in a town where I'm a stranger, there's time for thoughts to move and shift. Unusual scientific words run in my head in rhythms and harmonies. Eskers. Moraines. Muskeg and bays. The words go round and round, like the lines of the song we once sang. Dapples and grays. Pintos and bays. All the pretty little horses.

I walk past the fort to the back road looking over the coulees. Stand and watch the quiet.

Shirley calls. It's as if our day by the river requires its own coda.

For seven hours she drives me through the Peigan Reserve in her big pickup. Sometimes we face the Rockies far away to the west, always through golds and buffs. The sunlight is eerie. It shines from the west against banks of blue-dark clouds in the east, a dark aqua blue sky meeting golden hills, strange and amazing, light and dark all at once. Shirley points out white crosses atop hillsides, where long ago corpses were laid out for the elements and the animals to finish. She takes me to an empty space surrounded by trees, the site of the residential school where she and some of her sisters and brothers were placed.

Shirley tells me what it was like to lose both parents when she was young, of her father dying before her mother. She tells me about the pride her father instilled in her as a child, the pride of being a Blackfoot woman.

Our day is made of long meanderings down dirt roads, huge expanses and laughter.

We talk about men and our long single states. And I find myself beginning to tell her the story of the man who has become my nightmare. She drives as I talk, going slowly along roads she knows well. The steady motion and her sureness of her absolute right to be in this place encourage me to begin telling the story. I tell her about the night he called, about the battle I fought within myself, about grab-

bing my keys, helping Connor into the car, and getting out of there. I tell her I dreamt that he was buying a gun, that he planned to appear at my door and turn the weapon on me. After that night and those dreams, I reached out for the help I needed to protect my right to live in my own home, in my own territory.

It isn't an easy story yet, and there is no bravado in it, but as we travel on these roads I know I am safe to leave the realm of nightmare and enter the realm of story. I can feel for the first time that fear can also give me courage. It is just the beginning, a fierce and angry beginning, and as I tell it I feel the fear heavy in me begin to lift.

For a time we drive in silence. Tumbleweeds drift across the road and are caught up in fences. Topping a hill and facing the long distant chain of mountains, we are buffeted by a westerly.

Shirley stops the truck, at my request. She has spotted some buffalo, and I want to take a picture.

I ask if they are male or female buffalo, thinking some subtle differentiation in shoulder size will be the clue. She looks at me strangely. They're male, she says.

I ask how she can tell, as I concentrate on their massive heads, the strength of their shoulders.

Look down to the middle of their bellies, she says. I do, and then all the seriousness of our last minutes explodes into laughter, and it is a music that follows me into the wind.

The rest of the day, we talk about book launches and try to remember a certain writer's name. All day we interrupt each other, blurting out a name, an initial. And laugh even more because we know we didn't get it right. We talk about

writing about where we live and how hard that can be, about needing distance and perspective, needing to get away from home sometimes. We talk about cultures and histories, about her as native and me as Irish and Scots. We let down more barriers, talk about anything, everything: why most Indians don't have flower gardens, why most white women don't know they have a culture.

Jeez, I say, how could we think that when Sally, back home, danced so hard and kicked so high that her shoe flew off, right through the window of the community hall? How could we think we don't have a culture when we can dance that hard?

We'll stop and see Leslie, she says, and for a second I don't know what she means, or don't hear the name right, and then she pulls over on the dirt road next to a graveyard and takes me to her daughter's grave. An adolescent black dog lopes toward the graveyard in the confident uncoordinated way of young dogs. Shirley says that the day after Leslie's burial, when she went to leave a plate of food on the mound, two black puppies poked their heads up from amid the flowers. She says these dogs were considered a sign that her daughter had made her journey safely. The gangly dog coming to meet us is one of that pair.

From Leslie's grave, Shirley lifts the basketball her daughter's friends had covered in silken flowers; we smile, even laugh at the neat things people have put on the grave. As we leave, she tucks a cigarette, the gift of tobacco, next to Leslie's headstone and by her mother's and her father's close by.

A friend said that having the head of a Calvinist and the heart of a poet must make for a lot of conflict. When she said it, I didn't know much about Calvin or that the religion he founded was the heart of my father's upbringing.

When all this business of making the tapes began, I had asked my father, out of some sense of daughterly duty and honest curiosity, about his childhood. Partly it was a stock question. Partly I wanted to prevent the kind of regret I see in so many of my friends. They look around for answers about their parents' lives, and there is no one left who knows them. My dad is the last living member of his immediate family, as my mother is the last of hers.

I'm going to make him a present of the actual transcriptions. I will drill, as he did on the tundra, for the core samples that tell the real story. The pollen deep and rich in the bogs of peat.

He gives me images that make me smile, of growing up in Winnipeg, of frozen fish stacked like cordwood on the back porch, tells me how his father would chop off hunks with an axe. He tells me how eerie and frightening it was when he and his father worked together as night watchmen, patrolling the dark of a creaking warehouse. The blistering cold caused farm machinery and metal walls to crack like gun shots. They knew it, but still they jumped at the noise, could never be sure what waited around the next corner.

But the information that stops me cold in the anecdotes of his life is how strictly religious they were. That more than porridge or fish, religion was their daily staple.

Presbyterianism. Calvinism. I am astounded to learn that their lives revolved, almost completely, around the church, from the meals they ate right down to naming his brother Bruce after their minister. I didn't know this because our family had moved away from the larger family, and so the natural osmotic transfusion of history was staunched.

DAD IS ASKING *for a priest. This seems so unlike him, to ask for a priest specifically. A religious person, he says. A man. I would like a prayer. A retired priest comes. My sister Donna, my father, the priest, and an old family friend hold hands, say a prayer.*

IN OUR OWN childhood Dad sang hymns while he was shaving. From the hall we could see him standing at the sink in his short-sleeved undershirt and boxer shorts. Sometimes I'd go in, sit on the bench seat where the vacuum was stored, and listen to him. He sang in a church-singing way, serious and melodious, but horsing around, too, as if he were a big singer on radio or TV.

We teased him about listening to Tennessee Ernie Ford, who ended every episode of his prime-time variety show with a hymn. "Just a Closer Walk with Thee." "How Great Thou Art." But I didn't know that my father's faith and beliefs had once been deep and that his parents adhered strictly to Presbyterianism all their lives. That the church was the core of their life, the framework of their days. That finally,

when he and his brothers grew older, jobs and university and scientific training took them away from the daily life of the church.

Each Sabbath of his childhood marched Christianly onward from church in the morning to church in the afternoon to church in the evening. Their week progressed through Mission band, Bible stories, and prayer meetings. Although I gape at the regimen of church socials, church bazaars, presbytery meetings, quilting bees, charity work for the neighborhood at Christmas, visiting the sick and elderly year round, I am also struck by the similarity to my own life.

I stand looking down at the tape #3 in the cassette player before I turn it back on. These notions of duty aren't new to me. Where I live, in a long, narrow valley in the mountains, religion—with the exception of the Doukhobors—is not such a factor. But we have built community halls every five miles. We attend endless meetings, sing in choirs, raffle quilts. We hold walk-a-thons and dance-a-thons, build housing for seniors, tend the sick and dying, make our own weddings and funerals. We lead collective as well as individual lives.

I think about what we build as groups of people to combat isolation, about our need to come together to celebrate our lives, mourn our losses. I think of all our structures and institutions, about why we create them, then struggle to keep them going.

I understand this need for institutions. I have just never known the religious ones on my father's side. Our parents instilled a sense of duty in us, and god knows, none of us ever cast it off in the winds of individualistic pleasure seeking.

It is our duty to take care of each other. I believe that. I don't think it's fine for some and not for others. I would preach it from a pulpit if I had one. And with that rock solid foundation of care, we build our pleasure and love, our friendships.

I'm glad that we, and our communities, were never rich enough to cast each other off.

But even so, it's exhausting, and there are times when it is comforting to settle into someone else's structure, or stable hierarchies, just for a rest. There are times, when I'm traveling, that I'll enter an old church, rest my forehead on the pew in front of me, sit silently, listen to the music, admire the old stones and glass, glad for the comfort of their longevity.

The lines my father sang ring through my head: "Rock of Ages, cleft for me, / Let me hide myself in Thee." For me, this is not a metaphor for God but an invocation to the stones themselves. I think at this moment this song is an invocation to my father. He is the rock of ages, his work cleft for me, to let me hide in it and grow stronger for this while.

Yes, I understand duty, all right. But when it weighs too heavily, I want to tell it to go get stuffed, to get it off my back, find the laughter that lightens and leavens the whole tumble of life.

I GET UP, stretch, step outside the motel room door. A warm breeze plays with winter dust in the parking lot, sends it skittering around and down the back lane. Connor liked these windy places the best. The black feathers of his legs

would whip like a flag, and he would prance like a horse on parade. That extra charge of life, that gentle shove of the wind.

I look up at the sky, enjoy the unexpected warmth of this November day. It's 11°C. In B.C. there's snow, but there's no snow here. In Inuvik, it's 33 below. But right here, in the sun in front of the Fort Motel, it's warmer than Albuquerque, New Mexico.

I DID ASK DAD to describe the church he attended. I want to imagine it and him in it; he describes it right down to the stone, limestone, Tyndall stone, quarried fifteen or twenty miles from Winnipeg. Then he surprises me by singing the lines of their church's welcoming song from seventy years ago: "When the days go by and come September / You must remember St. Paul's as home."

I am not only surprised that he could recall the lyrics from that far back but touched that he would sing them for me. I haven't heard him sing since I was a child. As if true singing is too much an outlay of emotion. As if fathers, at least Scottish Presbyterian fathers, don't allow grief or pain or even joy to show too much.

DAD CAN'T HOLD IN *the emotions now. Somewhere, some-time, they started coming out. And then he can't return to keeping them all inside. After the plane crash, it's Dad who says some of the truest and most emotional words. He stops us all in our conversation, says: I have something I need to say. And we hold our breath, not knowing if he can make it through.*

I STOP THE TAPE. Remember those songs he sang while shaving, in his half-joking warbling way: "Were You There When They Crucified My Lord?" "The Old Rugged Cross," "Faith of Our Fathers." And we kids, from the distance of the living room, or from my perch on the bench over the vacuum cleaner in the bathroom, might join in before we fell on the floor laughing. But I still remember the tunes and rhythms.

After listening to this, I feel like I've been washed in the blood of the lamb or something. I also think more about my father's daily question. What have you done today to justify your existence?

I set out on my walk through downtown, all the way past the theater and the saddle shop, where I can see right out to the prairie, to its austerity, its lack of clutter. I wonder if this turmoil over the loss of Connor is a weakness, an indulgence in my emotions. I wonder if it's not a means to the justification of existence but a squandering of time and resources, almost a sin.

I turn abruptly and enter the door of the public library, go find the encyclopedia. Look up John Calvin.

It's like a skeptic reading a horoscope, that prickly feeling of recognition in the spine. How you distance yourself, scoff that the prediction could apply to anybody, but know that really, it's hit the mark. In reading about Calvin, I recognize my father, but more than that, I recognize myself.

John Calvin (1509–1564) preached duty to community, work, and the moderate usage of goods. He preached the right of resistance and the need to take part in the work of government. He put an emphasis on practicality, on loving

the good things in life but within limits, and on the belief that men are not superior to women. Most important, he believed that everyday work is the glorification of God.

All this gives me pause. If as a Calvinist I consider wallowing in emotion a sin, then how do I reconcile myself to the fact that sometimes I have to do that? I wonder if I could justify these emotions by taking the discipline of my Calvinism and the discipline of my art and welding them into steel. Make something of them. Make something of myself. I know my dream animals and Connor's death dare me to dig deeper to find my courage, to face the truth. I understand viscerally that I will not dishonor Connor or my own pride by seeking the protection of another dog or even the illusion of protection. There's an emotional strength I need to find, on my own. And if I don't do it, I will have failed. But I will not fail.

OUTSIDE THE LIBRARY, there's a sandwich board advertising bingo. It sure as hell won't justify my existence, but it looks like fun to me, and I scurry down a windy back street to the Elks Hall. I haven't played since I was ten, when cards had sliding windows, numbered balls rolled around in a metal carriage, and the caller opened the door to the cage for each number.

I race in from the cold. Everyone is seated and ready to play. Many turn to look up at me, the latecomer. A man missing his left hand sells me my cards, and I'm shocked by the twelve-dollar price of a big sheet of them. But I'm game for it, and he, sensing my enthusiasm and uncertainty, surveys the room, makes his decision, and whisks me over to a table full of pros who can help me. He quickly introduces me, the

women loan me daubers and introduce themselves: Dee and Joyce and Mary and her mother. Their purses are round like Ferris wheels, the outside a line of pockets packed with daubers and glue sticks for putting all the sheets together.

I find out that bingo is not easy. I can't believe that I keep missing numbers, that the women have to help me. The caller tells us to create the shape of a *Y,* the wineglass, which we do until someone calls Bingo! Next we do the shape of an *X.* We do lines across and lines down, and the shape of stamps in the corners, diagonal half-a-house and full diamonds and blackouts. My eyes cross and scroll: sometimes I almost nod off like you do when you've been staring at the road too long. I've stared so long that I have to try to spell the word BINGO in my head, B-I-N-G-O, to nod my head to help my mental finger find the right column, B-I-N-G-O, and then the right number, to mark it with my dauber.

It's like fishing, out on a big boat on the Atlantic, losing my equilibrium, trying to keep my balance, misstepping as I try to find the small rhythms and bigger ones, at the same time that I am so immersed in the detail, trying so hard to concentrate. The people who have done this a long time have the ease, the grace of finding the bigger picture, being able to focus even as they laugh and smoke and help this newcomer.

Only because they're watching for me, keeping track of all their cards plus mine, do I win twenty dollars.

The sheets all around me are covered in brilliant pink, green and blue splotches. Everyone throws theirs away, but I keep mine for souvenirs.

When there's a moment, the women ask where I'm from, what I'm doing. I don't tell them about Connor.

I let them think I'm slightly eccentric, a woman who has no kids, alone in a motel in a town where I have no relatives. Slightly eccentric and a crappy bingo player.

*T*his is a dream. Connor and I are in a school bus.

He is very old. We both get out. He goes far, far off, flushes and charges a bear, in a forest opening past a huge field of boulders: the Frank Slide.

The bear turns on him, but he chases it off. Elk and deer and moose emerge from the forest; they attack Connor with their antlers and racks. I am paralyzed, then begin running, scrambling toward him over that horrific obstacle course. I see him falling, gouged, then stagger up again, trying to escape. I reach him and help him home.

In some dreams he is mythic. In some he is frail.

After such dreams, in the cold light of morning, I know he can no longer protect me.

THE FIRST such morning was a lovely spring day. I woke to the pungent smell of sweet curry and ginger drifting through the forest air, mingling with the smell of cottonwood. I ran downstairs to find out what was happening: it was as if some glorious gypsy caravan had rolled along my back road in the night, casting exotic spices into the dark corners of my forest.

Instead, as I stood on the porch and looked out to the trees, I noticed that right next to me the lid of the freezer stood open. Yes, I reasoned as I turned to stare at it, trying

to reconcile the adventure hinted at by the spices with the odd reality of the open freezer; yes, I did open the freezer for ice for the two whiskies I drank last night. I was celebrating, or mourning, the last day of *Morningside* and all the work we had done in the Save CBC campaign: the speeches, the lawn signs, the candidates' forums. I downed two whiskies alone when it was over—not enough to forget to close the lid of the freezer.

Now I stood barefoot before it, staring, as if the open freezer would tell me what happened.

One of the large white baskets that hung inside, the one that contained all the spices, was missing. I looked down at the steps. Packages of meat and butter littered them, like debris from a ripped-open garbage bag.

Connor went into full alert, sniffed packages of food, my nicely parceled portions for a frugal single woman.

I picked up two pounds of butter, gashed through with long knife marks, examined them as if they were damaged in the warehouse, on sale. I realized that these weren't knife marks: they were claw marks. My mind registered the forest litter in the freezer, scaly cedar twigs and dirt and dark coarse hair snagged in frost along the sides.

I felt the hair on my neck rise. It was silent and swift, this invasion. In the night when this happened, I heard nothing. More frightening, Connor, who had always alerted me to danger, heard nothing.

He, however, was not alarmed, but in fact, acted like an opportunistic co-conspirator and grabbed a piece of steak. I could eventually forgive him his deafness, for missing the

bear's presence in the night, but in that moment, in my fear, I snapped at him. Go find the goddamned bear! I yelled. Goddammit. Listen to me!

I snatched bags from the ground, as if I were gathering fallen laundry.

But even while shooting glances over my shoulder, I noted what the bear devoured or discarded, found its tastes amused me so much that I could hardly maintain the frisson of fear. I quit my furtive retrievals and walked around surveying the scene.

On the stone steps lay two cardboard tins of sweet lime juice, shredded and empty. I thought of bear claws, dripping in the night with frozen green juice like slush, shoving it into its jaws. An image that struck me as both menacing and silly.

All the ice cream was gone, expensive vanilla Häagen-Dazs and a huge tub of cheap chocolate cookie. Frozen whipping cream and Nanaimo bars. Pieces of chicken and pieces of steak. This bear had come to me for protein and sweets, my freezer its cache of carcasses and honey.

A full bag of sauerkraut perogies lay gouged and thrown aside. Pesto, homemade, was scraped at and scrapped. In this chaos, I noted that the bear had rejected bean soup, freezer-burned corn and zucchini, old bags of bran and wheat germ. Every bag was slimy with saliva and coarse hair. All of it unsalvageable, and even in my shock, even as my hands touched what the bear touched, even as my hands were covered now with its saliva and hair, even as I understood that the food I eat is the food it eats, I could smile and thank it for ridding me of this junk.

I followed a trail, as if this were the story of Hansel and Gretel—shredded yogurt containers, tooth-marked bags of frozen milk, flakes of phyllo pastry and egg roll wrappers. The spice bags were torn and scattered. A hundred yards into the trees, I found the white basket, upright, like a picnic abandoned. Still full, it was heavy and large. This must have been a very big bear.

The perfumes of the Spice Islands blossomed in the forest air as it warmed, as I scrubbed away bear hair encrusted in frost, cooked up for Connor the meat I couldn't salvage for myself.

I locked the freezer, the first time in twenty-two years.

I would build for myself an illusion: that with a key, I could lock out fear itself.

Five nights later, I answered the phone. It was the call from the man, the call that left me no option but to grab Connor and get out. For several nights I hid the car where he wouldn't see it if he drove by.

DAD SAID they went out one year without ammunition. A case of mistaken assumptions that was dangerous but could be laughed off later. The man he hired to bring his rifle asumed Dad was supplying the ammunition. Dad assumed the man with the rifle would bring it with him. They traveled the entire summer in bear country with no protection. And didn't realize until the trip was over that they had done so. Dad made a good laugh out of it. Easy to laugh when there's a happy ending.

THE ADVICE is always so conflicting, hard to remember when you're alone and afraid. Run or stand still, play dead or fight back.

The bear didn't go away. It came back to my home the next night. That May evening, a grad party was wrapping up at the community hall next door to my house. Hundreds of teenagers roared their engines and pulled out of the parking lot. They had been happy and loud, and all seemed well, but part of my job is to keep an eye on the hall. It was a beautiful spring night. I left Connor asleep on the couch and stepped outside. The sky was clear and filled with stars and the parking lot light was on. I waved to the last car, walked to the meadow to check for debris or ruts in the soft earth. I glanced back at my house, where I can always see the small red light from the freezer, a comforting domestic beacon visible even through branches. But I couldn't see the light. I couldn't see the freezer.

Up the stone steps, a large shape moved swiftly, the way they say big men are good dancers. It had stolen in so confidently, overtaken the entry to my home.

Advice for each kind of bear. Grizzly or black. Fight back or play dead. The advice about one will kill you for the other. I only knew the sole object out there in that field, the only thing moving or emitting any scent, was me. If I moved it would see me. If I didn't, it might still smell me. I could never outdistance it, and I knew there would be no more traffic that night on this dark country road.

This bear had no fear of people, had moved into my territory from the forest within seconds of the crowd's departure.

Dad. Dad. The bear is circling my camp.

The bear tried to lift the freezer lid, but it was locked. It tried again and again, began to shake the entire freezer, gripping its width in its front legs, ripped it back and forth, scraping it across the bricks of the porch. From across the field, witnessing its hugeness and strength, I knew what it could do to me. The amusement I found earlier as I noted its tastes in food disappeared. I began moving, tried to make myself smaller, as if I could both run and play dead at the same time, kept glancing back as I rushed, in the shadows by the ditch, hoping it would not look out or stop its destruction.

Even as I chose escape, I chastised myself for simply not going back and yelling at the damn thing, standing on my hind legs and telling it to get the hell off my porch. But I could hear what it was doing back there; I remembered the claw marks slashed through the butter, and I slipped toward the lights of a neighbor a quarter-mile down the road.

Alley alley in free—the childish rhyme punctuated my breathing as I pounded on their door, please wake up please wake up. When I awakened them, I disturbed some equilibrium of dignity and care and distance we had always maintained. They came to the door in their pajamas. They are hunters, wildlife people, and I imagined, even in their concern for me, that they found me laughable, that they probably would have yelled that bear off. But they spared me this humiliation. Instead, they sat me down, reassured me that I'd done the right thing. Hungry bears are unpredictable, they said. After a long while, my neighbor asked if I wanted a ride home. I said No, no, I'll be fine, then Yes, and I was so relieved for a moment to accept his protection.

We got into his truck, the CBC came on automatically, some middle-of-the-night report from France or somewhere, and I savored those few moments, safe with a man I trusted, on our back road in B.C.

His headlights shone past my parked car up to my porch. The freezer was pulled from the wall, ripped off its moorings, would have been on the ground but for an upright post. Once more, it was covered with coarse black hair, with dirt and forest litter.

Connor slept. He had heard nothing. Not the bear. Not my return. In the morning I wrestled the freezer back into place. That night I set a large metal pot and wooden spoon inside my front door. Just as I drifted into sleep, I heard the freezer being shaken. I leapt from bed, ran raging and screaming down the stairs, You get the hell out of here! I grabbed the pot and pounded it and screamed and screamed through the old oval window, a crazed rural woman defending my right to live here alone, without a man, with a dog too old to help me. I was screaming my rage and fear, pounding the big blue canner as if my voice had the power to defeat fear itself.

The bear bolted, scrambled off the porch, disappeared through Oregon grape and wild roses. From this vantage, safe inside my home, looking through the thick oval window, my grizzly of last night transformed into a scared year-old black bear, its little rump bobbing through the bushes for all it was worth, and I began laughing.

If only it were all so easy. Make some noise. Reclaim my territory.

IN THE END, Connor couldn't protect me from anything. But the illusion of his protection was the scrim I held onto, the thin barrier separating me from my fears.

The man who frightened me made his late-night call, edged in on my territory. I grabbed the dog and ran. For days afterward I received calls and the caller hung up. Twice in one week I had been forced from my home, by a bear and a man.

My neighbor told me he saw the bear on his front porch. It was large and powerful. I was right to be wary.

I could have had the bear shot. The danger it posed would never be questioned. But who could I call about the man?

\mathcal{D}ad tells me how the railway was being laid north to Churchill. The advance crew buried cooked hams, coated with tar, deep in the cold earth. Safe from animals, the hams would later be retrieved and eaten by the railway workers. Decades after the railway was built, Dad and his co-worker bored deep for core samples and pierced into cooked ham, recognized immediately the history they had found.

He tells me how they made base camps along the Fawn River, stayed two to five days collecting plant specimens, made their notes on succession and topography, then moved twenty miles downstream and set up another camp. My father had so much territory, so many places besides our home.

He speaks of heavy portaging over glacial marine clays, portages of a few hundred yards or three-quarters of a mile, of twenty to twenty-five portages in one journey. They traveled the old trade routes, with stops at villages and trading posts. He came across ancient cairns, made base camps. The land was Precambrian, as old as the earth itself.

This was his territory, up north. Khaki'd and bearded, out in canoes, his job to bring home soaking wet pieces of plants, which he then took to the building. That's what we always called the science building at the North Dakota Agricultural College where he worked. Dad's at the building. Besides the Hudson Bay, too big for us to understand, the

building was his territory. I remember going there with Mum, pulling into the dirt parking lot behind the building, how Mum would let me go in to tell Dad we were there; I would run into the building as if it were mine, my head only as high as the rows of tables and beakers and microscopes I wound my way through. I remember that students and teachers in white lab smocks would know who I was, my father's daughter, and they would pause in their work, say hello as if I were someone special, and Dad would take off his lab coat, hang it up, lift me high. And then he would take my hand and we would walk out to the car.

And Mum would slide over as he took the wheel.

DURING THESE PERIODS *in the field, approximately three thousand collections of vascular plants were made, with duplication sufficient to provide approximately nine thousand herbarium sheets [sheets on which plants are mounted]. Along with this, as time permitted, data were obtained on forest composition, soil and peat profiles, permafrost features and increment borings on the main tree species in a variety of habitats.*

Determinations on the plants collected have been brought to completion through visits to the herbaria of the University of Minnesota, the Gray Herbarium, the National Museum of Canada and the University of Toronto.

THERE ARE SO MANY signals about territory—who walks into it as a natural and God-given part of their lives—where they get to explore and expand. And who has to struggle just to get past the kitchen.

There are times I don't understand why I need or want a man to be close to. I wonder sometimes still if the question is about the right to claim territory.

It's not about sex. It's not about needing a man around to do the physical work. I am competent on my own and bristle with anger when I hear anyone say there is something I can't do because I'm a woman.

I need, and feel I have to prove, all the time, that women—alone and in a community of friends—can take care of the business at hand. We don't need men to provide for us or direct us.

This notion makes me so angry that a good male friend's offhand remark twenty-five years ago about "wood widows," women who don't have a man to make their firewood, made me vow that I would never, ever depend on a man to buck and split my wood, and I never have. And because of this stubborn and prideful resolution, I have become strong, competent in using and repairing the chain saw, and the time alone in the woods and the visible accomplishment—cords and cords of firewood to heat my home—have been my reward. I get to do dirty, oily, bone-wracking work, with no one else's demands to consider. It is just the chain saw and me and the forest, the truck, and the deer.

I get to strip to my skin on the front porch, shedding wood chips and sweaty, oily clothes, throw them over a log or railing, step into a shower in the cool of the house, later start in on another project or go admire the product of my labor.

Visible, definite work in my visible, definite territory. As men have their territory, I too have mine.

I don't need a man to help me establish my territory anymore; I will not be forced to concede that because I live in the country I can only live in a male protectorate.

I THINK OF my father's buildings, his bivouacs, canoes, and cars and motels and classrooms throughout the Dakotas and Minnesota and Manitoba, where he taught in extension courses, driving through snow-blasted winter nights or dry summer heat. I think of the remote and wonderful settings like the Itasca biological station at the headwaters of the Mississippi River where he and Mum together, or sometimes he alone, took us to stay in the station's family cabins by Lake Itasca. We could watch students study the flowers and the animals, alive or killed and mounted. In the nearby town of Bemidji, we could thrill to the giant roaring grizzly, the nails of its huge paws forever slashing the air, as we stood below it, awed by its size but mightier, because it was dead and stuffed and silent. We were safe, and nearby the cash register chunked and clanked its reassuring chime.

As my father tended to his students, we ran through the woods on our own. In the safety of that wilderness enclave, we met hundreds of people, spoke with them on our own, learned where they came from, watched them at their scientific work. Our first day there, when a student cabin went up in flames, we learned how an entire community can come together, form a bucket brigade to the lake, where everyone—teachers, maintenance workers, students, and families—passed pails of water up the line, and if you were too young to bear the heavy buckets, you ran like the wind with the empty ones.

Sometimes all of my family was there—my mother and father, my sisters Judy and Donna, my brothers Brian and Andy. One summer just my closest girlfriend and I made the trip with my father. We were nine then, or perhaps eleven or thirteen. Dad taught his classes, cooked our meals, and kept general track of us, but we spent our days roaming the forest paths unattended.

The trail along the lake was cool and damp under our bare feet, the same path used by Richardson's ground squirrels, with their striped backs. Or skinks scooting to and from the water. We watched mink or marten eating crayfish. We left the dappled sun of the shoreline and slipped into the cool darkness of the forest to the shade and moss of the pioneer graveyard. We knelt before the gravestones and used our fingers to trace the names and dates, as if they were Braille. We called out to each other, or said, Come see this. We knelt silently, imagining the lives of young women our own age, who, in their isolation in this same wilderness, gave birth and then coped with death. We tried to imagine their grief at losing child after child, felt our own girlish grief as we read the names of their babies alongside their own on their headstones.

The women in these graves were children themselves. And then they bore children. And that was their fate and their life and the mark they made in history. Even as we left those mossy graves and sprinted shivering back to the sun and the lake, I thought about what marks we make on history and who makes the lasting ones. What marks the women make, which are made by men.

I remember a conversation overheard between my parents when I was a young teenager, a terse exchange as Dad built a room in the house. I stood near them, my dad in the doorway, my mother outside, looking in. As he drove the nail home, my mother said, You hammer a nail and it stays forever. I wash the dishes and I wash them again three hours later. I remember her frustration and his, her courage and anger in saying the truth at a time when women only were beginning to say such things.

The line shattered me, set my die, cast me forever. I vowed I would never, ever look back at my life and measure it by dishes washed. I would build and pack my own gray boxes, claim territory when I was empty and needed to be filled up again, and wash the damned dishes when I wished. And I would rage if anyone tried to confine me.

Although I ended up choosing both their lives, I know now that if, at that moment, I had had to choose which life I would lead, I would have chosen his.

I'M GLAD I ASKED my dad to make these tapes so that I can take them in at my own pace. Listen and jot and ponder and look for the larger picture, take comfort in the long view.

I walk miles each day, to the end of town and back, my life secure inside these motel walls. There is no clutter. No phone calls. Outside there is the stretch of the horizon.

It soothes me to understand that the view my father and his co-workers took could be both microscopic and macroscopic. That their minute inspection of core samples of compressed vegetation, peat thousands of years old, could reveal

the long view, the macroscope of history, of glaciers crushing the old growth, then receding to allow the new.

Or these men could lift their eyes from their work, look out to the bay, their view a long one.

I was involved in projects involving photography and all phases of microscopy and microtechnique, thin-sectioning of materials for anatomical and phytological investigations. I was involved in radio-carbon dating of material for work in connection with glacial geology, the advances and recession of phases, or moves, migration of vegetation; pollen analysis of peat bogs so that different types of vegetative communities, their phase of development through the postglacial invasion of vegetation, could be unraveled.

I wish I could apply this strategy in my regular life, take the long view when the minutiae of a day, an issue, or a community become too confining, too confusing. I want to take the small things and make them into patterns, into part of the larger flow of history. Or right now, simply take my own sorrow and make it all make sense.

We have to keep on going, even when it seems too hard.

MY FATHER and his friends explore, take botanical samples, make meticulous notes, exist on plain food like porridge, soup made from dried pork jowls. They plan, make bannock and biscuits, push on. But they also come upon delights, are treated to morels fried in butter, steaks from the tenderloin of caribou, treat themselves to fish baked in embers.

He uses the beautiful phrase, the wind-trained tree, describes the trees holding onto the steep sides of riverbanks against strong winds and the undercut of the current.

I think of the twisted spruce I've seen above the battered rocks and spray of the Atlantic Ocean. Or the bent and gnarled trees, landmarks along prairie highways, the ones that as children and then as adults we all knew as signposts of where we were and how far we had to go. I think how sometimes we bend to strong forces but also find that holding out against being overpowered, we mold our own strengths, become strong and firm. I think of my own father, and his aging, of all the old people I love, how their backs grow bent like wind-trained trees, but their hands are gnarled and strong, their grip holding tight. I look again to the image of the Burmis Tree above my bed. How it stands amid grasses orange in the prairie sun. Think of the tree in the gold winter light on Shirley's coulee. I hold the images of wind-trained trees and lifts of fish, of pollen preserved in peat bogs, of stories clear as amber.

My father and his friends are scientists and explorers. And as they tell their stories, they seem to me to be poets. They have taken the time to explore and the time to reflect.

That's what I am receiving here. Time to explore and time to reflect. Time to think. About lives closing down. Life opening up. About how I will move on, alone, when I get home. I look up from the tapes and the text, out to the changing sky, feel the shiver and power of possibilities.

GLACIERS RECEDE, earth rebounds, growth changes patterns, youthful rivers precipitate. I listen and transcribe.

The ice accumulation in that basin was certainly sufficient to bring about a depression in the crust of the earth through that massive area. After melting there was crustal recoil. At one time

the basin was much larger and had been gradually coming up and especially along the south shore, where the slopes to the ocean were very gentle. This gradual uplift provided a whole new land surface for the development of plants and beach ridges, which paralleled the shore. These beach ridges extend inland for several miles.

My father explains in more detail how Hudson Bay had been subjected to several waves of glaciation, how the ice, ever thicker, more than a mile thick, depressed the crust of the earth.

This wasn't a volcanic and cataclysmic event but slow, thorough, ponderous power. He tells me the most recent ice receded ten thousand to twelve thousand years ago, that the earth is still springing back, creating new surfaces, new ridges and shoreline. It is an image I like more and more, this process he calls glacial depression and postglacial uplift.

As I walk through Fort Macleod, unencumbered by meetings and obligations, past the theater, to one end of town or the other, to look out onto the prairie, as I turn myself with or against the wind, I think of my father's image, of wind-trained trees, of bending and holding in the wind. And I am glad for its strength and endurance. Then I play with the term I have discovered—the *windshift*. The word is so beautiful, the roll of it, the motion of air tumbling, like weeds rolling on the prairie, wind rolling, turning, shifting. I think of turbulence and change and let myself be turned by the wind, my back to it, then my face, let it buffet me.

\mathcal{D}ad said you can add and shift ingredients to make things change. When he was a child, a preacher at their church in Winnipeg showed them that: how the soul could be cloudy and lost. And then how you could clear away the doubt and confusion.

The kids at his church loved the preacher, "an itinerant preacher," Dad calls him, a stranger to the congregation. He strode to the front of the big church, insulated and cool inside its heavy walls of Tyndall stone.

The preacher opened his black valise full of odd beakers, with balloon-shaped bottoms and narrow necks, with cork and rubber stoppers. Like a wizard, he mixed chemical reagents; with acid, changed a blue liquid to red, warned the children that this was the devil himself invading the soul. With a flourish, another reagent added, he produced a milky precipitate: the soul in confusion and doubt. With another, he cleared the precipitate, purified the spirit, cleansed the soul.

The children sat there, mouths open, awestruck. Spinning his allegory of good and evil, souls in doubt, souls lost, souls saved, the preacher gave them the miracle of a story.

Dad called it the chemical sermon. Me, I think of it as the time when science and poetry held hands.

I COULD PICK UP the phone and call Anthony. But at first I don't. I crave male company, as if somehow I need it to round out the small and controlled society I have created for

myself. Anthony and I have talked once since our summer almost-romance, so it isn't absurd that I should get in touch again.

I crave the closeness, the sweet intelligent lovely easy-goingness that men so often wear like a comfortable sweater. I crave the teasing, lovely, brotherly sisterly sure knowledge of each other and of what sets off laughter.

But I am testing myself in Fort Macleod: asking for help seems too much of a weakness. And I am afraid our summer acquaintance can't bear the weight of my winter's need. That once again I will be rejected.

I think of Anthony though, when I am out walking. I look at a place, cold and dirt-strewn, where we walked in the summer. When I feel the sun on me, I hear again the screech of the gulls as they dove for our chips. I hear his laughter. Or, in the warmth of a restaurant, when I feel so lonely, I remember how we simply sat talking and laughing.

I could drive the few hours to his home in Calgary, but I will not stray from my fort.

FINALLY, WHEN IT IS cold enough that there should be snow, when December is so close, I call Anthony. It is a risk. Another test.

But I think about that pilot on Hudson Bay, his heavy cargo, how he revved up the engine, made some waves to step up on, to lift from the dead calm, and fly. It is time for me to make some waves.

To my relief, Anthony finds nothing strange about how hard Connor's death has hit me. Instead, he says what I need to hear but find so hard to square with myself: that Connor's

death may be the hardest loss I will ever take, the first big one that will knock me down and teach me to get up. Again and again.

I tell him I am preparing to leave Fort Macleod but will wait since he is coming down for the caroling and Christmas parade. Still, I distrust myself, wonder if I am still playing at romance or seeking protection from what I have to face going home alone.

At that moment, I can think of few things more comforting than standing in the cold prairie wind, muffled and close to Anthony in the midst of a crowd of strangers, raising our voices together. To hear his beautiful voice again and mix it with my own. As if the song, the harmonies, would signal my arrival at strength and peace.

I want the singing, the whole notes and rests.

THE NIGHT OF the caroling, I bundle up against the prairie wind and head downtown. But Anthony doesn't come for the singing.

I stand alone in the cold, surrounded by other people. The wind is fierce, mean, relentless. It has gathered power crossing the coulees, and we are its first obstacle at the end of Main Street. There is no huddling, no lifting my voice in communion. I sound like a person alone who can't find the harmony. I feel like a fool, who has foolish adventures and romantic notions. I am the naïve one who hoped to take her accordion on the canoe trip.

That night I lie in bed and can't sleep, paralyzed again with grief and even greater loneliness, the small loss of not seeing Anthony a reprise to the greater loss of Connor.

I never saw Dad cry until our family dog died. We had had our dog for eighteen years, almost our entire lives as a family. Dad emerged from the bedroom, his eyes red, and it dawned on me, a teenager, that the death of our dog Dinty was the first time I had seen Dad lose control of his emotions.

I curl around a pillow as if it were Connor, imagine the comfort and strength of him, and weep and sing. I sing "Hear That Lonesome Whippoorwill." I sing it to my dog. I sing it alone.

In the morning I rise very early, stand outside with my coffee to watch the sunrise.

Go home, old woman, and bury your dead.

I don't want to be a needy person. But I need to be touched. I need a safe place for my last undoing. I need someone to take me in their arms and hold me, and I believe Anthony is that person. I don't know how else to ask for help except to ask for help. Anthony, please help me. I crave comfort from him, as if he were the last reagent needed to clear the confusion of my soul.

Irene sees me standing at my door, tells me Anthony called late the night before to say he couldn't get here until today. She didn't put the call through because I was sleeping.

It would have made my sleep easier, but how could she have known? And knowing he will arrive soon, I let my solitary strength of the early morning slip away.

Early that afternoon, Anthony arrives at my door. He asks if I am okay. Do I want to go for coffee? No, I say, I'm cold and want to stay inside.

I show him the surrealistic buffalo Shirley gave me, the pictures I took in the coulees. And then, sitting by him on

the bed, I tell him how awkward I feel, that I am usually a strong woman who likes being on my own. But right now I need him. I tell him how I have been strong this week, have laughed and walked, how Shirley has been my company. But I know that I want to be held. And I don't know if it's even fair to ask him.

Anthony turns to me, holds his arms out wide, wraps me in them. And we lie on the bed and he holds me. He puts his arms around my shoulders and strokes my hair, holds my hands. He asks me where Connor got his name, and I tell him. He lets me cry long and hard. He asks if I'm okay, and I say yes. Is he? Yes. Once I kiss him on the cheek. Sometimes my hand caresses his waist, his chest. Or his hand lies across my breast. We are fully clothed, yet this intimacy is a great act of love. He falls asleep and he holds me and curls around me so that we are like spoons under the blanket I pull over us. For a moment he snores. I smile at the strangeness of it. This whole week. Of the strange comfort I've sought, these unlikely friendships, the comfort of strangers. I have needed someone who will ride next to me, or hold me, but not try to take over my grief or relieve me of its responsibility.

It's as if I could see the animals who have inhabited my dreams turn their heads back toward me, their bodies alongside Connor's as they help him to walk on his own. And they say to me: You also have passed our test. You haven't let yourself down. Now you can go home stronger, alone.

ANTHONY AND I lie together all that afternoon. We talk about our everyday lives, our friends and our homes, the choirs we've sung in, the hours we keep. We talk of the

mundane and the profound. I tell him I miss laughter, tell him about the fear with the man I once lived with, about the tiredness of this last year, about losing Connor.

Late that afternoon he drives to Lethbridge to see his niece, and later I head to the family dance at the Elks' Hall, the fourth event I have attended there this week.

Parents and kids dance together, and kids dance with kids. The Macarena, the chicken dance, the limbo.

I simply get to sit there alone and smile and laugh. While I am not actively included, I feel the privilege of the dancers' acceptance, of being allowed in.

EARLY ON that sunny and windy Sunday, I walk out on the prairie to take a picture of the sunrise. It is as if the sun has waited for me, held onto its color until I am ready. The pinkest moment of the morning stays with me for the space of a breath, lasts no longer than Connor's dying, then leaves me standing alone.

At a gas station on the edge of town, a truck driver hails me. Are you heading west? he asks. Yes. They need an extra load of *Lethbridge Herald*s in Brocket, he says. Can you drop these at the Napii Mini Mart? And take one for yourself? Sure, I say, and head toward home with this one small chore to perform.

PORTAGES

1 9 9 7 – 1 9 9 9

\mathcal{M}y father's stories are always about far places, where my mind can imagine and rest. They are not stories of daily frustrations and petty fights. They are not stories of love or hate. His images are large and cool, focused and delicate. They challenge me to breathe deeply and rebuild.

In his stories, there is no death. In his stories, planes don't crash. No one drowns. No one stumbles with exhaustion.

In real life we stagger and fall, and get up again.

My father's stories help me now, more and more in retrospect. Each death is the ice growing thicker. Each time we take each other's hand, we help to lift the glacier from our backs.

My older sister's husband, Michael, has died. He died before Connor, but it seems these many years later that the sequence of events is no longer the issue, but what we learn each time, whether we stay standing.

This was the moment when we began losing the men in our family. Of course we couldn't know it. The story hadn't been written. But it was the beginning of losses that would test our strength, our ability to hold on and grow stronger like Dad's wind-trained trees. To find our laughter again, our desire to go out into the world.

When Mike died, Judy and their son William tried to revive him, but there was no bringing him back.

I drove to Minnesota. The rolling hills and trees carried me along, let me think of what was ahead.

Last time I saw Mike he was in the kitchen in his wheel-chair. He wasn't given to sentimentality, but he and I were alone that afternoon and he looked at me and said, Make the time to enjoy your friends and family. They matter more than anything.

THE SIDE DOOR is open at Judy's house and I walk in. McKinley, the burly golden retriever, large and built like a bear, more red than gold, draws back his lips, bares his teeth, begins a savage gnashing and barking.

McKinley! I say. Who do you think you're talking to?

And he looks shocked, contrite, and switches into over-sized dog squirming, all over me, bumping into me, dancing around, as I kneel down, put my arms around him.

Judy, my big sister, my wonderful, tough, funny, strong big sister, comes to check out the commotion; then we embrace, brush back the tears, and she takes me to the front room, where she stands over all their kids, who are there with their kids, the whole extended blended family, sorting through hundreds of photos. There are photos of Mike everywhere, on tables, on the floor, in albums, in shoe boxes. Mike at political meetings, Mike at the lake, always in the midst of kids and cohorts, part of the big extended Irish community of St. Paul. He and Judy had even planned a trip to Ireland, but in the end weren't able to go.

Judy is comforting people, receiving comfort, cooking, crying, laughing, making phone calls, all at the same time.

I call Dad and Mum next door to tell them I'll be over soon, go back to the car, get my bags, haul them up the narrow steep back stairs to the third floor, with McKinley shoving his way alongside me, up these stairs that Connor needed help on, next to the rail and the empty chair lift that took Mike up and down to the second floor.

Later still, Judy and I walk across the lawn to Mum and Dad's house. Before we step up to the door, Judy pauses, turns to me, breathes deep into her lungs, squeezes my hand, sets the tone before we go in: Well, she says. Now I am the Widow McLaughlin. Maybe we'll make that trip to Ireland after all. I take this signal from my sister, walk in smiling, chin up, carrying on.

Inside, Mum and Dad come and hug each of us, and we sit down on the rockers, and more family and friends arrive to greet me, the most recent arrival, from farthest away. They ask about my trip from B.C.

Everyone is still in that first part after a death, the part where people arrive and first they ask about your trip, and then they tell you how the person died, and who was where, and who did what, so somehow you can get to the same starting line together and move forward from there. We're in the part where everyone has to get sorted and in place, and then proceed as a family. This is the part we can be so good at, the crisis, where we become family again, and know our roles. The dessert makers and the drivers, the woodworkers and the storytellers, the strong ones, the funny ones. I know at some point this week, my sister Donna will make her famous lemon lush dessert, Brian will

sit and talk with Mum, Dad and Andy will go down to the musty basement shop and turn out some wood product, and Judy's sons David and William will be with her every moment they need each other, and one night we'll all cook a huge supper for everyone. And someone will buy bags and bags of licorice. We'll get to that. We will.

In the kitchen, alone with Dad, I tell him I'm glad he's made his tapes. Well, he says, I hope those musty old stories are some use to you. He stands leaning with one hand on the sink, reaching with the other to turn on the tap. I notice how his veins stand out. Old person hands. Strong hands still, the veins ropey and thick. Dad has lost so much weight these last years. He's gone from the slim and strapping young man of his stories to being a very heavy man, almost 240 pounds. Now he is down to 135.

Dad drinks his glass of water, says it was a job to make the tapes, that he'd had some trouble with his old recorder, but David and William gave him a voice-activated model that made all the difference. As we rejoin the others in the living room, Dad walks slowly, stooped and small and frail.

The guests have all gone home now, and the family dogs are grabbing the limelight in the middle of the braided rug. My parents' small dog, Casey, is performing the completely bizarre yet amazingly sweet grooming ritual of licking McKinley's teeth. It's a performance we've seen dozens of times, and as always, we groan and say, Casey, Don't! as he hops around McKinley's face.

The dogs have broken what small amount of formality remained, so it feels perfectly right to tell my story, to convert it to a party piece, to let it serve this purpose for a while.

I was in Fort Macleod, I begin. There is an old theater there.

And I tell them about the play, about meeting and walking with Anthony. They know I haven't been interested in anyone for years, so this is good; they are keen for this news. I play it up for them, deliberately shock my upright young nephews, David and William, who are both scandalized and bemused by their Bohemian Canadian aunt. They like this fine, me, the dolt romantic, my first time in a few years having so much as a cup of coffee with a man I find attractive. I tell them how we walked by the river, what we talked about, and how we threw chips to the gulls. And then when I get to the part in the car in front of my motel room, my mother says, You mean you would have, you would have . . . and Judy says, Yes, mother, that's what she's trying to tell us.

This is my family I'm talking to here, and they know me and my loves and my failures as well as I know myself. When I get to my blundering proposition, Judy throws back her head, laughs and laughs, wipes tears from her eyes from the laughter. I would do anything for her. If the story weren't true, I would have made it up.

THE MORNING OF Mike's funeral, we go down to the basement and haul up every lawn sign from every political campaign the family has taken part in and hammer the signs into the lawns again, as we have done in so many campaigns before.

At the graveside, it is William, just seventeen, who says the last words on behalf of the family. After the burial, hundreds of mourners come back to the house, walk through

that patchwork colored sea of signs, maroons and greens, oranges and blues and reds, up the front walk to the sounds of a bagpiper. As a big family we walk together, and you can't not cry. Cry and smile all at the same time. Because of the energy, the belief, the life represented in every one of those signs and all those people. The victory, perhaps, or bitterness, or bitterness overcome. Defeat put long behind. And always some hope ahead.

In my family, politics, community, food, and tradition are our mainstay, inseparable. Inside and outside, there is food and drink and tables of people who have been to this home many times, who will be here many times again.

My sister greets, hugs, and thanks every one of them.

IN MY ROOM alone at night, this room on the top floor of Judy's house where I have stayed so many times, I think about my sister a floor below. Alone now, in her own bed, without her husband.

We are both women alone. We have family and many friends, but still, we are women alone.

AUGUST 1997

𝓜y friend Sally says that pockets of time open up after a death in the family. Lovely pockets of time when no one expects anything of you. There is time for walking and thinking. Time for rebounding.

The Minnesota State Fair, Minnesota's Great Get Together, is on a few weeks after Mike's death. Judy and I understand that if we go to the fair, she may not be able to make it through. Every sight and smell of corn-on-a-stick, every 4-H display, every home-improvement show is going to be something she and Mike enjoyed together for twenty-five years.

Let's go for a little while, she says. Maybe a few hours and we'll see.

I realize how very tired my big sister is, the one who can always be counted upon for laughter, toughness, pushing through. We are seven years apart in age. She is the first-born. I'm the fourth. She has always been out there, a few years wiser, stronger, and funnier. But her adrenaline is used up now; her laughter isn't ready.

We start the State Fair with funnel cakes. Funnel cakes are made by pouring batter through a funnel into a deep fryer. The golden batter spreads like hot lead hitting cold water. It floats on the fat, a big deep-fried curlicue of hot cake, lifted and drained and sprinkled with icing sugar. Then we line up for deep-fried cheese curds, globs of cheese also dropped in hot fat. They are hot and cheesy and salty.

Just right for passing back and forth, the sweet funnel cakes and salty cheese curds, as we walk through the wide shady streets of the fair while the morning is still cool and we wander and watch.

At the Department of Natural Resources bandshell, the Polka Lovers of America and the Heartland Swingers dance to the Wee Willie Band. The best polka dancers from all over Minnesota, on a big plywood dance floor on the ground, swing each other around in their red and white and green outfits. Among them are the King and Queen of Polka from Anoka. The women's skirts twirl so high that their underwear flashes, some red, some fancy white, some plain and chaste. With the reds and whites and greens, it's like watching Christmas swirling in the midst of the green trees, people in their fifties and people in their eighties, who have danced together forever, a sea of good-natured people whirling and laughing at the bad jokes and good humor from the polka band. They switch partners, return to their own, and each pulls someone in from the crowd. They do it again and again until the platform is full and people dance on the grass. My sister and I are smiling, and the woman next to me tells me about her square dance club back home.

At the livestock barns, we learn we have missed the chickens. It's the second year we've come on the chickens' day off. Even chickens get a one-day break from the stress of the fair, from the hundreds of thousands of people and the strange noises; we are grossly disappointed, my sister, who never much looked at a chicken in her life but who likes them for my sake, and me, who's raised all kinds. I crave their society sometimes when I am troubled. I like their

officiousness, their broodiness and boldness, their completely self-absorbed chickenness, going about their business for all it's worth. Golden Buff Orpingtons and black Harkos, black-and-white Barred Rocks, Rhode Island Reds, the all-purpose leghorns, even the broody and flighty banties. But instead we walk among cages of lop-eared bunnies, their long ears like the best kind of bunny ears you could ever want to hug to your chest.

Later a girl in the 4-H building stands in the traditional 4-H demonstration stance, behind a table, her props ready, her speech practiced enough to be relaxed and sure. I recognize the style, the excitement and readiness, standing up straight and confident, delivering your performance. I bet her mother knows the speech by heart and stands near the back of the crowd, hands clutched, discreetly mouthing the words. Up front, the girl holds her black rabbit to her chest, tells us what to feed it, how to keep it clean, what to do and what not to do. Cradling her own rabbit gently, she reaches below the counter, pulls out another bunny, matted and flat, whacks it onto the counter. We all draw back in mild shock. This is what it looks like if you don't take care of it, she says. We all lean in to look closer. It's a worn-out stuffed toy rabbit, probably her own, probably one she slept with and drooled on when she was a little kid. I admire this girl's theatricality, how she hooked us and made her point, and wish I were a judge.

Somehow, in contrast to other years, Judy and I don't meet a single person she knows. Not one person who says they are sorry for her loss; who she, in turn, would console. And I believe that for these few hours it's a relief.

We go to watch Cliff Brunzell and his Golden Strings. They are all dressed in white. They are real performers, thirty-four years together, in hotels and fairs, at big weddings. They've played at Judy and Mike's home before. They are very Minnesota, with their sense of modesty and propriety and fun, and I realize how much I like Minnesotans. Minnesota Nice, my nephew says, self-deprecatingly, but you can tell he's proud of it, too.

The drummer plays the piccolo in John Philip Sousa's "Stars and Stripes Forever," with flourishes and teasing. When another song begins, a couple gets up in the crowd of seated people and polkas under the hot sun. As we move into the shade and breeze, the band slows the music down, begins playing "It Had to Be You."

My last memory of Mike and Judy together is New Year's Eve. In their home. Hundreds of guests. Music and dancing and colored confetti. Mike greets everyone, feels great. Judy stands by him, at the corner of his wheelchair. They are laughing together, greeting all their old friends.

Beside me, my sister is weeping. I move closer, do not touch, pass her a Kleenex as we stand listening.

And then, because this band is so good, because they are artists who can take us so far inside ourselves and then help us out, they know exactly what we need—something fast and clean—and my sister and I are smiling as we head to the midway.

It's very hot now. Although neither of us likes fast rides, we love to hear the screaming and shrieking kids. Last time we came to the midway, we found a game our speed, and we look for it again. You place a big floppy rubber frog on a

springboard; then with a large rubber mallet you pound a lever. The frog sails up into the air and lands in a tank of rotating lily pads. The goal is to land your frog on one of them. We slam the mallet hard over and over, yell, Come on Frog!, watch the frogs fly and splash, aware of someone nearby winning, cheering her on. We're concentrating so hard, laughing so hard, splashed with so much water. I look at my sister and love her more fiercely than I can understand.

Back by the bandshell where we began the day, we sit in the shade, sipping coffee. Judy weeps as she watches the lineup for the Pronto Pups—they're just hot dogs deep-fried in batter. It's the smell, the memories. And I say, Had enough, Jude?

She says no, and we're off to see the art fair, cast ballots for what we like best, pen anonymous appalled notes objecting that they did not include her son-in-law's artwork. Then we're off to the quilt show and home arts to stand stock-still before the thousands of jars of preserves in their display cases, back-lit so that pure clear light shines through the yellows and purples and reds of the jellies, as if they are stained glass, and we stand in awe, as if we have entered a cathedral.

By now it's four o'clock, and tired fairgoers sit on benches, staring blankly ahead at the home arts demonstration booths, even though there are no demonstrations going on. I nudge Judy and we smile at the sunstroked, grease-stuffed, sore-footed zombies, who cannot take in the sight of one more quilt. Then I seek such a bench myself, fighting the sunstroke, the greasy food in my stomach, cracked lips, sore legs, remembering how this came on last time, too—suddenly battling nausea, willing myself not to give in. I sit

in front of a large electric fan, hold very still and breathe, wave my own green four-leafed 4-H fan, head, health, hands, and heart. I know, even in my momentary misery, that there is happiness here, too. I concentrate on the empty woodworking demonstration booth before me, concentrate on the straight dependable line of the countertop where there is no one demonstrating anything. Judy watches over me until I signal to her, one hand up, my eyes still straight ahead, that I'm okay, that she can leave me. She walks over to look at some more quilts.

On the way out of the fair, we watch the fair parade, Clydesdales and oxen and kids marching in brass bands. We buy egg rolls at a booth we'd noted on the way in. We sit in the cool grass. The egg rolls taste like Spam, and we laugh at that, too.

WHEN WE GET HOME from the fair, Dad's in a panic. He can't find something he wants to copy for me. The original of a major study of the north, by a famous scientist, Eric Hultén, who, in his foreword, pays tribute to my father's own work and personally signed the copy of his book with thanks to Dad. Dad says this is the greatest acknowledgment he has ever had. It strikes me as disproportionate to consider this one line of acknowledgment the greatest tribute to his life, but it clearly is upsetting to him that he can't find it.

He is slumped in his big leather chair trying to tell Mum where to look. She, too, is frustrated. Doesn't recall what the book looks like, since she hasn't seen it for many years, doesn't know where to begin looking amid the stacks and shelves of books.

But he showed me this book just recently, and I find it for him in a second, just two feet from where he's sitting. I don't understand why he couldn't find it.

GLACIERS RECEDE. The land recoils. Connor is gone. Mike is gone. Eventually a brain tumor will claim the life of Mike's son, John. And the family will grieve again.

A year after Mike's death, my sisters and my mother and I travel to Ireland. It is our first big trip together, all women. I am the only one who can drive the rental car, which has a stick shift. Judy navigates. Mum and Donna are in the back. We drive into a big city on a Friday afternoon. Everyone is honking and the streets are so narrow. We are lost. I become crazed and angry in my tiredness, but Judy, who knows exactly how to handle me, is not cowed, begins laughing until tears roll from her eyes. She laughs my fear and anger away, as only she is allowed to do. And I say, I'm only making left-hand turns until you get me out of here, and she does.

Another day, I am the one who takes care of her, when she is exhausted from trying to make the pilgrimage for both her and Mike, convinced that we can't make it, that the drive to the isolated place she needs to find is too hard. When she begins to weep, I become her big sister.

I pull to a stop, say: Pass me the chocolate. Take it in like fuel, like a good 4-H girl, to my head, to my heart, to my hands on the wheel, to our health. I say, We'll get there. And we do.

In County Donegal, I climb high up on a cliff over the ocean. Judy comes with me so I don't have to be alone. And for herself, she needs to be there, too.

Far beneath us, battered by the ocean, is the Giant's Chair, a rock as old as the earth.

We stand in the wind. It twists and plays, scratching through the heather, billowing Judy's coat.

I'm wearing my old leather jacket, the one I wore on the ferry across Kootenay Lake when Connor died. I pull a small plastic bag from my pocket, open it and hold it out to her.

She digs her hand in. Then so do I. Both of us are crying, each for our own reasons. But we're smiling too, remembering the vet's stupid story. Then we throw Connor's ashes to the shifting wind.

1999

\mathcal{A}t Christmas I give my father the verbatim transcripts of his tapes. Everyone knows what Dad is about to open. The transcript is simply presented, in a plastic binding, with photos my nephew David has scanned from the days of Dad's scientific adventures. Dad at his lab, Dad in a canoe, in his anti-mosquito campaign spray truck, in his graduation gown, holding his diploma.

Dad's face fights with pleasure and tears as he removes the wrapping paper and sees what's inside. He winces and cries and smiles and digs for his cloth handkerchief, as if he has to balance all his emotions in that moment, to retain some control.

Mum helps him, opens the transcripts and reads him a few paragraphs, while the rest of us move on with opening our gifts, affording him some time to regain his composure.

I understand my father more now, after transcribing his tapes. How he influenced us. How lucky we were as girls to have a father who loved the earth and believed we should, too. How we grew up with the freedom to explore river valleys and lakes, on our own or with men by our sides. As I look at my parents sitting together at Christmas, I am so grateful that they never hobbled us like little princesses or crippled us with fears. Mum and Dad encouraged us to explore our world and report back on what we found.

Dad's Calvinist question, What have you done today to justify your existence? told me I could do things worth

doing and therefore worth telling. That I should and could justify my right to exist. That females, too, could become explorers. Stake our claim and be strong. Sometimes we will hold like wind-trained trees. Sometimes we'll get knocked around, and then, at the windshift line, we will struggle and embrace change.

IN THE DAYS AFTER Christmas, I notice that since Dad's stories are down on paper, now that he's perfected the anecdotes, it's as if they have become his set piece. He is far more likely to repeat them to friends and strangers alike. His script is written, the rehearsals complete, and now he is ready to perform.

My father was not given to telling us stories, but I realize that his precise recollections of his work in the north, his well-polished anecdotes, the stories of his family's strict Presbyterianism, his distance and longevity, have been the stories I needed so badly.

I can even smile as I recognize in my writing my own form of Calvinism, my need to seek the precise detail, to find the uplifting moral, then work until the poetry of it emerges from the elements.

I sometimes feel my father's arms around me, patting my back in comfort and approbation. More often it's his hands I see, demonstrating some woodworking skill at the lathe, holding a board to examine it just so, or placing a slide into the microscope, adjusting the focus.

There are moments when I can see the poetry in my father, as if I could become the itinerant preacher, as if in my conversion of him to story, I could select the reagent, and

with alchemy I could clear away his frailty and doubts. I could give him the strength of a wind-trained tree, release his stories from the gray box with its trays and rope handles and the scent of old canvas, sing him like a hymn. His stories are my chemical sermon, my science and poetry. His Presbyterian discipline, the detail, the centrifuging and thin-sectioning of materials required to behold the wonder of life through a microscope, the botanical specimens, the Latin names, and the beauty of pollen and amber—they become the poem.

BACK HOME IN B.C., I plunge myself even more into the life of my community, my work and friendships. I am not lonely. My life is rich with friendships and the outrageous laughter and solid companionship of women.

I dedicate myself to the concept of safe homes and secure territory for the older people in my own rural community, and head a fundraising campaign for our first seniors' housing project.

Sometimes, at public meetings, at the parking lot of a building supply store, even from the dentist's chair where I sit trapped and distracted and looking out through the window at my car across the street, I see the man I once lived with. He recognizes my car and glances in, then walks on. If we pass each other on a crowded sidewalk, we practice mutual nonrecognition, a survival tactic in a small town. I steel myself to him, breathe deeply, push his heaviness from my chest.

When he tries for the last time to enter my dreams, when Connor is no longer there to protect me, Shirley appears in-

stead. In the dream, this man almost draws me back into his orbit, almost wraps up my mind. I can feel myself beginning to believe him again, become afraid that I do not know how to resist. But just past his shoulder, out of his range of vision and directly in mine, Shirley begins to make faces. She's clowning and sticking her tongue out, trying to make me crack a smile in this serious photo. Her strength is so much greater, so much deeper and truer than his, and my own wish to be released from his hold is so strong. Her smile tells me, Just let go, just laugh at him.

I do smile. And the man loses his power over me. Poof, he's gone.

THE WINDSHIFT LINE

2001-2003

\mathcal{D}ad develops an obsession with sewing machines. He finds them at yard sales for five dollars. He spots unused ones in the homes of relatives and badgers us to carry them home. He is up to four sewing machines. Every machine needs work, and he is fascinated by their potential and their deficiencies. He wants to fix them. He wants to sew pant cuffs. He phones the sewing machine store, which is many miles away at the edge of the city, sets up an appointment, then announces this arrangement. I lug the heavy machine to my parents' van, drive him to the small mall at the edge of the city.

The next machine has trouble with the tension, and he is uncertain how to thread it. He calls my mother upstairs over and over to help him. Finally, I relieve her of the duty, and with some old and half-remembered training in 4-H and Home Ec, thread the machine. Dad leans over me, tries to help with the tension and figure out why the thread binds and knots beneath the foot.

It binds because it's a goddamn piece of shit, I want to holler, and the stupid piston is seized! But he thinks he can fix it, and barely able to see, he asks me to help guide his hand. I want to storm out in frustration but instead hold his hand, help him guide the screwdriver to loosen just the right screw, and then with his hands he divines how the piston should rise and fall, how the bobbin should shuttle, with just this one adjustment.

The third machine has only one bobbin, and we have to go way out to that store again to see if it has others. We walk among machines that are computerized, have multiple threads and bobbins, can spin and weave, make lace and embroidery. We walk to the counter, Dad in his old sailor's cap and the green sweater he now must wear always. And he holds out the bobbin from his old worn-out machine.

THAT SUMMER OF 2001, Dad is diagnosed with Alzheimer's. Mum sits with him as the doctor tells him it is Alzheimer's, but Dad tells the family in elaborate and scientific terms that the good news is that it isn't. That the brain scan showed a small hole, but it isn't Alzheimer's. For a time we skate around this, trying to buy time for all of us, to adjust ourselves. When he steals handfuls of peanuts and butterscotch candies from the bulk bins at Cub Foods, shoving fistfuls into his coat pockets (and he always makes sure to wear jackets with extra pockets), we either cajole him into putting them into a bag and paying or we prepare to rise like mother bears in his defense. Were anyone to catch him or humiliate him, there would be a brutally protective woman to contend with. But still we joke among ourselves: How can you find Dad in the grocery store? Look for the flying peanut shells.

We attend Alzheimer's information meetings without his knowledge, concoct elaborate on-the-spot lies about being at an all women's meeting at the Y when he wants to know where we all went. We allow him the dignity of pushing away the Alzheimer's news and ourselves the time to get our act together, for just a while. But we learn there are drugs he

needs to take, and if he doesn't believe he has the disease, he won't take them.

ONE WEEK, Dad and I go to the lake so that Mum can have a break and Dad can see his friends. I feel that once more he is the father in his element, in control, pushing for what he wants to do when he wants to do it. The minute we're in the cabin, he picks up the phone, passes me an old cardboard card with the numbers of his friends written in big letters. I read them out, loud and slow, for him to punch in. He's back at command central, in touch with all his friends at the lake, making arrangements, all of which mean I have to do stuff I think is absurd or dangerous.

He wants to hitch the trailer to his old unlicensed truck and drive up the back road to pick up a rototiller, and no, don't bother securing the trailer doors, that rototiller won't fall out, it will be fine. I ignore him and secure the back doors the way I think they should be secured. He wants me to drive his truck down onto the beach so he can see the water. No, we won't get stuck, he insists, but we do. He wants me to back the truck into the garage amid the chaotic rubble of old mowers and boats and the junk collected over thirty years. Dad, who is almost blind, will direct me. Come on, just do it!

There is a moment I am not proud of. There's something wrong with his truck. He wants me to look under the hood with him. Fetch tools. We start arguing about whether it needs a new part or whether we can fix it. I am so god-damned angry, because I can't win. I can't reason with him. And I lose all patience. The Alzheimer's support group may

tell you not to argue, because you'll never win, but when you're head to head beneath the hood of a truck with your father who has Alzheimer's, and you're not sure if this is his own pigheaded manipulative self operating on a highly functional level or the disease making him behave this way, there is little grace in the discussion.

You're always right, aren't you? I yell. You're always goddamned right!

He demands to know what makes me the goddamned expert. I say because I know how to do goddamned things, too. Or something equally inane. I am at the point of tears. He is exhausted. Somehow we get the truck going again, and with him directing, I back it into the garage. Most of the stuff in there has already been banged into before anyway.

Back at Judy's, I tell her the story of the confrontation, of Dad and me under the hood, how goddamned infuriating he was. She opens the fridge and pulls out a bottle of wine. After a few swallows, I look over at her. I did not bear my cross well, I say, and that is it. We both lose it, end up with our heads on the table, laughing.

WE CAN'T CONTINUE this way. In the end, while Andy is visiting in November of 2001, we hold a family conclave.

Judy takes the lead, gently asks Dad to turn off the TV so we can talk.

We need to talk about your health, she says.

Your health? he asks.

No, Dad. Yours.

She says that while we're together—and Brian would be here, too, if he could—we need to talk about this.

She says we know he has been diagnosed with Alzheimer's.

No, he says, that's not the case, Judy.

Well, Dad, we're aware that this is what the doctor is saying and we need to face it together.

We all take our turns then. We say that he's a scientist and we're realists and we'll face this as a family, just as the family faced John's cancer. That we know it is scary but that there are some courses of action we need to get going on. We tell Dad that we love him and that we'll be with him all the way. That sometimes he will lead, and sometimes one of us will take the lead for him.

There's an Alzheimer's family meeting we could all go to next week, Mum says.

He sits in his leather chair, and we know right now, right at this moment, he can accept reality or reject it.

I guess you have given me an ultimatum, he says.

We look down at the floor, at each other, then at him. He is so small in his big leather chair.

Perhaps I heard the doctor wrong, he says. And I am willing to go along with you.

This was so hard. This was so easy. And we sit there almost speechless, almost deflated, as if we had built our adrenaline up for this, and he has agreed so gracefully. How do you follow that one?

Dad does it for us.

On that happy note, he says, what should we do next?

Judy says she, for one, is ready for a glass of wine. I second that emotion, and we go get wine and treats left over from the last wedding she catered and bring them over to

Mum and Dad's house, and we celebrate what we've just come through together.

The next week we attend the Alzheimer's family information night, and Dad is the hit of the class, as if he is defending his Ph.D. thesis. Of the twenty or so people attending, he is the only one who actually has the disease, the only one with bona fide qualifications. Every other family speaks of its loved one at home, but we are the champions. We are all there with him, and when we introduce ourselves, he is the best.

Ross Moir, he says, Potential Candidate. Everyone cracks up, and Dad laughs so hard he gets red in the face. It's wonderful. He asks the best questions. If he's going to have Alzheimer's, then by god he's going to be a star.

I BEGIN READING Dad his stories from the manuscript of this book. Mum sits in his big leather chair, and Dad is right next to me on the couch so he can hear. I have to read without looking at him. It is too hard because I know he is crying. I can hear him right next to me, can hear him pulling his handkerchief from his pocket. Sometimes Mum says, Maybe that's enough for today. Sometimes I say it. Sometimes Dad says he likes how I got the glaciers.

I ask him the correct pronunciation of the Latin and the meaning of the names.

What's *Rosa acicularis*, Dad?

Acicularis? That's spiny, he says. Spiny rose.

Equisetum sylvaticum?

Horsetail, from *equus,* equestrian, horse. Sylvan, of the woods.

Epilobium angustifolium?
That's fireweed.
Habenaria orbiculata?
Orchid.
Petasites palmatus?
Petasites? I can't just recall that right now. *Palmatus?*
That's a palmlike leaf.

ON ANOTHER DAY, Dad and Mum and I walk to the nearby
Minnesota History Center to see the new exhibit on torna-
does. Inside, we stand in line waiting to enter a small room.
As we wait, we can hear the tornado, and already I can feel
the ground shaking as the storm comes, the sound and feel
like a train coming, and the impact ahead. As we wait to
enter, we look at a huge whirlwind shaping beside us, a large
funnel made of kite material: it begins twirling, enlarging.
And as we read signs that explain the science of the phenom-
enon, we hear noise from inside the room, the crashing and
roaring. The people emerge, dazed, shaking their heads.

We enter the small, darkened room, made of cinder
blocks, like a basement. There is a workbench attached to the
wall, with tools on the surface, a hammer and chisels, with
jars of nails screwed in above. There's a small space heater
on the floor, an old television set, and one bare light bulb
hanging from the ceiling. There are two benches and a par-
tial staircase for us to sit on. One small window in a window
well, with the edge of the sidewalk visible above, allows the
eerie light in the sky to seep in. We huddle in the basement,
Dad between Mum and me on the benches. We watch the
darkening light through the window. The TV comes on and

begins to broadcast news of the tornado throughout the state. We see the wreckage, the panic and bravery.

Then the tornado comes to us. The single light bulb and the TV go off. The light from the window goes dark, and the sound grows louder and louder, the roaring shaking the room, and trees crash and glass breaks, and all you can do is breathe, just breathe, and know it will be over. We sit huddled, waiting. The sound stops. The tornado is gone. We sit in silence, all of us, and watch the light change at the window. To an eerie yellow, like after you've been hit, the color of a bruise. And then the light becomes more normal, the air lightens, and you can feel it in you, how your breathing eases, and we stand, shakily at first. And then we file from the room, saying, We've done that before, lots of times, haven't we?

This is the honeymoon of Alzheimer's. When Dad is funnier, more relieved and playful. We make a trip to the ocean, and we walk into the surf with him and he laughs as the waves catch his shorts, almost pulling them off. He never turns down any adventure. He enjoys everyone and everything. He enjoys Christmas lights on banyan trees and coconuts along the roadside. We sit in a small park, and he explains to me how the xylem and phloem work in palm trees. He and Mum sing us a French song together that they learned in grade school in Winnipeg and likely haven't sung since. To the tune of "Twinkle, Twinkle Little Star," they sing *"Quand trois poules vont aux champs, / La première va devant, / La seconde suit la première, / La troisième va derrière"* . . . The chickens follow each other, one, two, three

into the field, and while we clap and cheer, my parents smile at each other, and I know there is no gift in this world I would trade for this moment.

It is as if Dad is having not a second childhood but a first. There is no regimen of church and mission band, no strict adherence to Calvin's rule of constant work. He is playing in the surf, laughing and singing.

At the same time, he is re-creating himself, nailing down the memories, new and old, putting his stamp on his identity.

These are the good days, not the hard ones at their home in St. Paul, the ones Mum is the most likely to see. When he asks the same question over and over. When he turns the radio and TV up so loud she can't think or find a corner of the house that is quiet. When mice get into the house, and Mum tries to move the furniture to find their droppings, and Dad gets up to help and trips and sprawls on the carpet and needs help to get up, and the dog starts barking and chaos is so fast and overwhelming. Or the days he sits staring, or falls asleep, head drooping.

There are still days, however, when Dad is content. He tells me he was at a garden center with my sister Donna's husband. As he waited for Steve, a woman turned the corner, saw him sitting on his bale of hay.

You know she saw me in the sun, Dad tells me later. Maybe it was how the shaft of light hit me, sitting on that bale. But she stopped, and she said to me, You must be a scholar. It meant so much to me that she would say that. She was such a nice woman—I think she managed one of the stores. She must have stayed with me for ten minutes and

she was really interested. I told her about working on the Hudson Bay. I told her about all you kids and where you live and what you do. It was just a nice thing for her to do, and it meant so much to me, that a stranger would stop and talk with me.

These are good days for me, too. It is hard for me to believe, but I am falling in love.

After years of living alone, I have come to peace with my solitude. I even love it. But on the worst days, my daily dose of courage is tapped out. I cannot force myself to make a social arrangement, in the long winter can't bear the thought of driving out the snowed-in driveway one more time just to share supper with someone, and I ache for daily companionship. I miss my sisters and brothers, my family, feel that I am again empty from their nest. I crave bursting-out-loud laughter, the absolute certainty in moving through a day with someone I adore.

I want the tenderness of a lover and friend, a domestic life with all its comforts and joys, cooking together and talking, nestling under a blanket on the couch and reading books out loud to each other. But I can't go out and find someone. It doesn't work. I have decided that if the right man doesn't come to my front door, then I will live my life independently and singly in the midst of a community of friends and the love of my family.

And then, of course, he does come to the front door.

It is a cliché that love happens when you're not looking. The man who comes to my front door is an old friend. It's a summer of renovations and construction at the community hall next door, and he's the blacksmith making the wrought-iron railings for the front porch.

His name is Dan Armstrong, a wonderful name for a blacksmith, and I suppose it is his arms that I notice first. I hear a truck pull up, and he stands at my front door. Through the oval beveled-glass window, I see Dan, in a ragged old black cutoff T-shirt and black cutoff pants, his shoulders white where the sleeves once were, his legs white from his cutoffs to his wool socks. I haven't seen him much for a decade. His black hair has gone white and gray. His eyes are still the same dark brown. He's got the railings and wants help lugging them out of his truck.

They're big and heavy—he's worked for months on them in his shop, designing them to fit the look of our community hall, to suit all the building inspector's demands for railings used by children.

We walk from my house to his truck, out in the sun, and I tease him about his clothes. Decided it's summer, eh, Dan? Cut down your black winter outfit to your black summer one?

He looks at my own old work clothes, ragged black tank top torn at the armpit and boob, blue jeans worn through at the knees.

You're quite the fashion plate yourself, he says.

It could be one of my brothers talking.

Yeah, but I'm tan.

I crawl into the back of his truck, amid the detritus common to all our trucks, bark from firewood, gravel and bits of hay. And with him reaching from outside and me hefting from inside, we hump the railings up over the tailgate that won't open.

There is an ease in how we move together. We've grown up in the same culture of hard work, of women and men building things together. We expect and understand strengths and, on the best of days, accommodate weaknesses.

We have known each other a long time—have each come and gone from this valley—there was a decade when we were only vaguely aware of each other's whereabouts. It's not surprising I don't know that he and his wife have separated but learn it by happenstance a few weeks later.

In this summer that he is building the railings, old and new friends work side by side repairing the hall, tearing up and refinishing the basement, rebuilding ramps and sanding and refinishing floors. I help lug material, organize crews, see the jobs through, take photos for our hall's continuing slide show. Throughout July and August the hall rings with the sound of sanders and hammers and laughter.

One day when Dan's work is almost done, he asks if I have ever gone kayaking. Yeah, I say, a few times on the lake. Not on the river.

Do you want to go sometime?

I'm nervous about kayaking, hate it when people expect something and I can't deliver. Hate it when they expect me to take stupid risks because they do on the fast rivers around here. But more than that, I don't know what's going on here. Is he just asking me to go kayaking, or is it more than that? Last time a man asked for my company, it was Anthony, five years ago, and I certainly misjudged that.

Sure. Sometime. Give me a call.

It would be good to go soon, he says, while the weather holds.

I have to check my calendar, I say, and stumble toward the house.

Several days later he pulls into the driveway with two kayaks on his old Dodge Dakota. We head up into the mountains to a small lake. The lake is calm, manageable. I tell him the ground rules. Show me but don't push me. Don't do stunts or make me try anything dangerous.

Our day is wonderful. The lake is just big enough to be an adventure, to paddle around or across, with small reedy areas and one small stream to push up and explore. We see beavers patrolling; we see a bear amble along the far shoreline. He offers help if I ask questions about how to paddle, how to get in and out, but he never dominates. I never find myself swearing under my breath at him to let me figure it out myself.

We explore some shorelines together or separate to check out whatever attracts us and then find each other again; hold our paddles across each other's bows and drift into the lily pads, watch lily pad bugs doing lascivious things together in the sun.

Weeks later, we kayak on the still part of the river in the moonlight. We drift silently past trees clinging to the shoreline, hear beavers slapping their tails in the night. We drift by people sitting on the shore, past lights and campers, the park where couples or groups of friends gather in the evening to watch the river. We could call out to them, but we let the river carry us in silence—that connection, that separation, strong enough.

We have times together and times alone. We begin to make firewood together, and this transition from doing all the work alone to working as a team seems so easy.

There are times he stumbles and takes my offered hand. There are times my old Husqvarna won't start and I'll hand it to him.

One morning, squatted on my heels and peering deep into the lower shelves of my ancient refrigerator, I topple over backward. I'm sprawled on the floor laughing so hard I can't move, and he, laughing just as hard, hauls me up.

I feel as if I have not let down my barriers, have not truly talked, for years. We talk nonstop. We talk about our families, the jobs we've held, about art and work and politics and the need for solitude and the need for friends.

One night we drag an oversized foamie and blankets out to the field and watch the Perseids. While meteors shower above us, and deer huff and snort nearby, we talk about the extraordinary, the stars showering over our heads, and the mundane, old refrigerators and septic systems, and in our comfort and laughter, I believe I have found my mate. We simply match together, like old socks that finally end up in the same drawer.

He asks me to go to a potluck some old friends of his are having. The theme is Jamaican. Okay, I say, you find the recipe and ingredients and I'll help make it. He brings a Jamaican banana bread recipe, which includes lime and rum and coconut. My old oven overheats, and the bread rises and begins burning within ten minutes. The smoke alarm screeches and the house fills with the smell of burned

bananas. The bread itself looks like cinder bricks, and there is nothing to do but turn the oven off, let them cook slowly, and see what we can salvage.

Dan takes the bricks to the back porch with a saw, cuts off a half-inch all around. Inside, the bread is sweet and tender, but it is useless as is. It has no form or beauty. I head to the Co-op, buy coconut cream pudding, whipping cream, and nuts. Come home and cut the bread into slabs. We lay down a base of whipped cream, a slab of bread, more whipped cream, and then a layer of fresh banana slices and more whipped cream and coconut pudding. Layer after layer in a tall glass casserole. We top it with pecans browned in sugar and rum, lime, and butter, crumbled and sprinkled over the swirled cream. It is stunning, a miracle of salvage and mirage. It's our first domestic disaster, our first recovery.

We stand looking at it, wonder what to call this, our burnt offering, when people ask.

Banana Creamatoria, he says, and I know now, if I didn't know it before, that this is a man I can love.

\mathcal{D}ad can't get out to do much work any-
more. He cuts up cardboard boxes for recycling, but then
sometimes after all that work, he just throws the bundled flat
boxes into the regular garbage bin, where Judy rescues them
later. Sometimes he stumbles on the cracks in the sidewalk.
But still, he likes the details of what everyone else is up to,
such as the work we're doing at the community hall.

What kind of wood are you laying? he asks on the
phone.

It's already down, Dad. Quebec maple. We're refinish-
ing it.

That's good. What kind of finish?

Varathane.

High gloss?

Semi.

What about the railings? Won't they rust?

They're rust coated.

It's kind of neat when there's a crew working together,
isn't it?

Yeah, Dad, you'd like it.

SOME DAYS DAN is here with me. Most days I'm alone or
working beside the crews at the hall. All the work has to be
timed so that the weddings booked during the summer will
take place on pretty grounds, with cut and watered grass,
without piles of wood or scrap to trip over.

I'm outdoors every day cleaning the site, hauling and burning scrap at the big bonfire. I'm turning brown as a berry and shedding weight. I scour the paths in the forest, clean out windfall and brush, haul rocks to and from gardens. Some days I roast a smoky on a long stick, sit on an upturned log and drink black coffee as I enjoy the smell of smoke at my fire.

In these moments I think of my father. The time he came upon the burned embers of a fish shed. How in the embers as they spread the live coals, they unexpectedly laid open a fish, there in the coals, cooked to perfection. The white of its meat a delicacy below the charred skin.

I walk into the hall. I am awed by its beauty. I love the wood. The gleam of the maple floor, with its new coat of reflecting gloss. I love the sun streaming through windows, warming the floor and the creamy browns of the cedar walls. I love the smell of the newly cut cedar, the reds and yellows of the fir on the outside decks.

If Dad were here, he would run his hands along the metal railings Dan made. He would check the rivets. He would tell me about the woods of Quebec where the maple was cut. He would examine the joins of the double-paned windows built right here at the hall.

I have always understood my mother's love, so immediate, so familiar. It is really only now that I understand my father's love. He gave me my love for the land and what it produces. For what we can make with what we are given. The confidence to stake my claim in my chosen place. To fight for it when necessary, to battle fear whether it comes from inside or without.

Alone in the middle of the large dance floor, barefoot, I lift my arms to my imaginary partner. I sing a song my parents used to sing and start to glide—one-two-three, one-two-three—"Casey would waltz / With the strawberry blonde, / and the Band played on, / He'd glide 'cross the floor / With the girl he ador'd, / and the Band played on . . ."

I sing alone, but I don't feel lonely. I am where I belong, by myself or with a partner, and I have so much to be thankful for. I twirl around and around the floor, then push open the back doors, sit on the steps, look out into the cool of the forest.

My father's stories, his passion for the plants and the water and the newly formed earth, have helped me lay claim to my place in the world: here, in this valley, in this forest, in this house I built. His infusion of belief, his insistence that we get out and justify our existence, was a push to believe in myself and my right to exist. He inoculated me with the belief that I get to stand on my own two feet in the world and that I shouldn't be bullied or ruled by fear.

I am proud of myself now. Not so ashamed of the confusing and possibly dangerous situation I bought into long ago. I refused fear. I pushed it out my door, got rid of the man who frightened me. I declared then and there that I didn't need a man to help me lay claim to a place and that I would not let a man drive me from my place. I will love and I will love deeply, but never again will anyone make me afraid in my own home. No one will ever bully me again, with silences, with coercion, with booze.

My father's stories gave me somewhere deep and intricate to go while I figured things out, figured out how to be

alone. His stories relieve me and soothe me with cool Arctic air. All while assuring me that life will go on and change, and I have the right to be, that my existence is, indeed, justified.

There are even days when I feel some small inclination toward gratefulness to the man who made me afraid. There are times I see him on the street, and he looks old and heavy and sick. I don't know if he is. I don't want any contact with him yet. Sometime perhaps, to be absolutely completely sure I am rid of him. I have no sympathy for him, but I am strangely glad he came into my life. Because what he got away with and how far I let myself bend shocked me. Because of him I initially distrusted, then regained trust in, my own judgment. Because of him, I thought things out and rebuilt. He tested my strength. He taught me what never to tolerate, not even a little bit. He taught me where snares and traps lay. He made me ferocious.

What happened with him I will never let happen again. I will never again mollycoddle a man. I will never cater to a man's anger, or potential anger, or probe a thousand times to find its core, the rings and layers of the dangers in those depths.

He taught me where to draw my line, where strength comes from, who it comes from and how we offer and receive strength. From the Shirleys and Judys who claim and inhabit their territory, from the Anthonys with their stories and songs. From the hand offered. From walking shoulder to shoulder.

This horrible man pushed me to understand what would be involved in ever loving again.

I have lived alone for five years since Connor died. I think I have proven myself to myself. Years in which I have passed my own tests, found my own strengths, my endurance and gentleness. I am ready to love truly and deeply again.

IT IS A TIME FOR rebounding in our family. Judy tells me that William, too, is falling in love.

He has been interning for Senator Paul Wellstone, is working on the senator's campaign, has fallen in love with a wonderful young woman, a campaign worker, and this time it's for real. He has built Judy a fish pond which she'll stock with koi, and he's building stone walls for Dad and Mum's gardens.

Life seems so sweet, so full of possibilities after this hard time we've all been through. There is death and birth, aging and renewal. As Dad loses his strength and power, William is coming into his own. In my own life, there is new love and laughter, and the family is regaining its equilibrium.

It's as Dad said; glaciers recede, and new life grows in their wake.

*J*udy and I are preparing for a trip to Prague. It is our big adventure.

William is living at home during the campaign and can take care of the house while she's away. Dad is taking his Alzheimer's medication, and it seems to help, so there is no crisis there. Judy has bought our airline tickets; we'll leave in two weeks. The trip is beginning to seem real.

On October 25 I stop for medical insurance at the travel agent in Nelson. She asks where I'm going, and when she realizes I don't have a visa—that Canadians must have a visa to go to the Czech Republic even though my American sister doesn't have to—she sends me home immediately to retrieve my passport while she sets up an emergency dossier pickup and starts making calls to embassies. It's going to cost a lot, but without a visa I will have to forfeit the trip, won't even be able to board the plane.

At first I'm stunned that I have made such a mistake and that it could have cost me the trip, but then I roar into action, gun the engine the twenty-eight miles home, shoot upstairs, and grab my passport. The light on my old brown answering machine is blinking. I curse and hesitate. It never plays back properly, and I can't take the time right now. But I grab the cassette, slam it into another tape deck, stab Rewind and Play.

It is my mother. Her voice is the voice I have never heard in my mother, a voice shattered and desperate.

Honey, honey, please pick up the phone. It's Mum.

(Oh god, no, something's happened to Dad, I think. Oh no.)

It's an emergency.

There's been an accident.

I think William has been killed.

In a plane accident with Paul Wellstone and his wife. It's unbelievable. Please pick up the phone.

There's a long pause.

Call Judy, then, Honey.

I CAN'T GET THROUGH to Judy or Mum or Donna. I phone Andy in Nova Scotia. Brian in Winnipeg. Finally get through to Judy. She is calm. In shock. The plane went down in northern Minnesota, she says. Everyone on board is dead.

I call the travel agent, tell her to forget the visa and get me to St. Paul.

Dan drives me the four hours to Spokane, where we spend the night before the next morning's early flight. He stays with me as I pass through security, and then I'm on my own.

In the airport restaurant, with a few other travelers scattered at various tables, the TV is on, covering the plane crash. It is the only news, everywhere, on every channel. They play a clip of Paul Wellstone speaking, and there, suddenly in the background, leaning against a doorjamb, is William.

That's my nephew! I blurt out. That's William!

But in this airport I am alone, and strangers don't know what to say.

That's when I did my crying, that moment in the airport.

William's half-sisters pick me up in St. Paul. They take me to my parents', where everyone is gathered. It is the stunned and shattered gathering we cannot bear, but must bear.

Mum is at the door and folds me into her arms. Dad struggles up from his leather chair, holds me to his small and fragile body. Judy is called away for a conference call with all the families. She takes it on the back porch, in the sunroom Dad built, where there's some privacy. She comes out and tells us that no plans can be made yet for funerals. The crash site is under investigation. The FBI and National Transportation Safety Board are on site. The remains won't be brought home for days.

EACH MORNING William bounded downstairs, hollering out, Bye, Mom, I'll call you! Every day he called Judy to report the excitement of the moment. Where they were, who they were meeting. He loved and respected and sparred with Senator Wellstone, as he had done with his own father. There is a picture of the two of them together, Senator Wellstone and William. They look like they could be family, the way people do who love each other. The senator knew Mike well, told William the stories about his father that he needed to hear.

That morning William as always ran downstairs. Bye Mom, call you later!

They would fly to Eveleth in northern Minnesota and be home that night.

An hour later Judy went shopping. She was catering a big wedding and was buying the last-minute groceries. The car radio was on and she heard the news. The senator's plane had gone down. Numb, unbelieving, knowing it to be true, she wheeled around and headed home. A campaign staff member was waiting there to meet her with the grim news.

THE STATE OF Minnesota is in shock. All on the plane dead. Paul and Sheila Wellstone, their daughter, two campaign workers, the pilots, and William. The deaths are horrendous personally, devastating politically. Paul Wellstone is the only federal representative in a tight race who voted against the war in Iraq. There is an election in ten days, and he was the only one who had the guts to stand up to George Bush.

The night of the crash, thousands of people gather outside the state capitol building, just a mile from my sister's. The next day when I arrive, there is a long scheduled peace rally on the steps of the St. Paul cathedral, at the end of her block. A friend arrives at my parents' and asks if we want to go, and he and Judy and I walk down through the crisp autumn air. We climb to the top steps of the cathedral, where we can see for miles. A rally that would have drawn hundreds is drawing thousands.

It is cold but sunny. Thousands and thousands of people stream toward the cathedral, and from high on the steps we watch them, in their coats and scarves, alone or in groups, carrying their Wellstone signs, and some carry signs with William's name, too.

DAD SITS IN HIS leather chair. He struggles for words, not because of the Alzheimer's, because it has never robbed his language. He struggles with emotion, trying to master it and the words he chooses to describe his grandson.

Dad holds his hands out to describe the stones William set into mortar this summer. His hands stay like that as he grapples for words, and we don't know whether to leap in to help him. But we don't. We hold our quiet. Dad is crying and his hands are shaking. It is almost unbearable not to help him, but these are words he has to say himself.

Dad draws on his huge power of intellect and poetry, and he describes William:

William was a builder, he says. In our family we are like bricks, strong but sometimes crumbled, sometimes scattered. William was the new mortar in our family, and he was beginning to hold us together. He had matured from a headstrong and sometimes sullen young man to a mature man. He was watching out for others.

Dad's hands move up, as if he is gripping air, as if he is placing them on William's shoulders.

You could see it each day, he says. William was mellowing and putting other people's needs first. He was a new element drawing all the parts of this family together as he grew into who he was. He was strong, so strong in all the right ways. He was growing up to be such a fine man.

Dad is crying. We're all quiet and crying. This loss is too hard to believe.

The family, the huge extended family, and hundreds of friends, the millions of Minnesotans who are mourning, create somehow a sheen of life, of tears and flowers and cards

and memorials and more tears and laughter, that keeps us from dying. Some of the families travel north to the crash site, and our family places roses and a picture of William there. The photo of William and the roses replays over and over whenever the crash is on the news. I look out from Judy's office where I use her computer. She's at the kitchen table, her head down on her arms, her shoulders heaving. She is silent in this agony. Has turned the sound down, but the images repeat. The crash site. The photo. The roses.

I LIE IN HIS ROOM, a narrow bed surrounded by his clothes and shoes. His trophies and photos. Electronic gear. We are all in shock. There is no way to comprehend the simplicity of the fact. The plane went down. All eight were killed.

Did they look at the lakes as they flew? Or were they too wound up in campaign strategies?

Did you lean forward to talk to someone, William, or did you look out the window, take in the trees in their October red, the ten thousand lakes of Minnesota blue against the dark black spruce. Or did you have no opportunity to study the features in that area. Did you suffer, William, or did the trees take you swiftly?

NOBODY IS SLEEPING. We are haggard, but somehow always there is laughter, too. Somehow your body shuts down the crying. There are so many people to be comforted. So many young people experiencing this first horrible raw pain in their lives. They need the gift of laughter. You can't keep crying. You just have to stop. You just have to clench your hands, breathe deeply, and fight it.

Friends send stupid jokes on the Internet. Dan and I write back and forth several times a day. Sometimes when I am upstairs, I hear laughter below. David and Judy talking and the sweet sound of their laughter that will take them through the next horrendous stab of pain. The grandkids still chase each other around the house. One is just learning to walk. People gather with food and cards and photos of William and all their offers of help.

There is grief and there is anger. These deaths are political deaths. They come in the midst of the biggest, toughest race there is for the balance of power in the U.S. Senate.

At a memorial for all the victims, where people who care about politics arrive by the thousands and thousands and thousands, there are speeches that move us through every emotion imaginable.

David makes a beautiful and wrenching and funny eulogy to his brother William, and as he speaks, a picture of William appears on the huge screen overhead where the television camera broadcasts the memorial service. The camera moves from David delivering his speech to the photo of William, then down to my father in the audience. It picks him out again and again, this old and grieving man.

Then there is a speaker who makes us cheer and cry and stomp our feet and rise again and again in pain and joy. He gives us catharsis that will carry us through the horrendous weeks ahead.

The right-wing media seize on this speech, call the event a disgusting rally, call it a political disgrace. They were in trouble, because Paul Wellstone opposed the war in Iraq,

and he was their main opposition. They had to be careful during a time of mourning. Now the right can drop its façade and go for all-out power. George Bush arrives to campaign for his handpicked candidate, for his war, for his God-given right to walk in and take over whatever territory he pleases. Now the politics are pure and brutal; there are no more false tears for the victims of the plane crash.

I stand outside George Bush's rally, a Wellstone pro-choice sign in my hand. I'm here on my own, among a lot of peace activists I don't know, but I have to be here, to make this statement, even to hold one sign. I need to stand here in this cold, to bear some kind of witness, to see if I can manage to do this kind of thing again. I'm wearing my button with the picture of my nephew and the senator, a button each member of my family wears. Thousands emerge from the rally, waving American flags and yelling at us to get jobs. They look at my pro-choice sign and yell at me that I'm a baby killer.

A gray-haired woman walks toward me with her husband. She looks at my Wellstone sign, then directly in my eyes, and says triumphantly, "He's dead," and walks away.

For a moment I am paralyzed in my anger and pain and rage. I walk after her. I place my hand on her shoulder, turn her around, look into her eyes, and say, My nephew is dead, too. On that plane.

As if somehow she would care. As if I truly believed that somehow this would shame her or even make her think.

I am a fool to think these things. I am so glad my sister did not come to this rally.

THE FUNERALS are held. The funeral for William is on Thursday, October 31, the only day of the week when there are no other funerals from the crash. Several thousand mourners come to his wake. They stand in the street outside the funeral home, in the freezing cold, in lines winding around the block, lines so long the police arrive to direct traffic. Judy stands near the closed coffin, in the room full of flowers and the photos of William, and for six hours she greets and holds and comforts every person in that long, long line.

The plane crash was ten days before the election. In the midst of this carnage and mourning, the eight funerals and the huge memorial, a new candidate must be found and a shattered campaign staff has to carry on.

With my family, I work election day. My sister Donna, my mother, and I go door-knocking to get out the vote. Every family member is doing something to help. Even Dad is out making sure the Wellstone signs stay secured in the front yards. We stand at bridges and wave signs. We do anything we can to join the people who are struggling forward under this burden of loss.

We stay late into the night at the hotel ballroom where the results come in, and they are not good. Overnight there is still some hope, but by morning it is gone. Judy and I sit at her table, staring at the newspapers. There is no victory snatched from the jaws of despair and defeat. There is no feeling that all these good people did not die in vain, or that somehow, somewhere, if we believed in such things as the hereafter, we could believe William would be smiling.

There is no image of comfort. No god in heaven. There is only getting clobbered across the head until you can no longer feel any more pain. There is only loving each other that can get us all through this horror.

Our mother and father have held through this. Held as if they have linked arms and woven a safety net, as if this is their last and greatest act together as parents. They are our wind-trained trees; they have not fallen or broken. Through the Alzheimer's and the grief and exhaustion, they have held their arms out to their children, gathered us in; they have been the parents and grandparents every family should have in these horrible times.

\mathcal{T}hree weeks after the funeral, Dad starts to complain of stomach pains and begins to drop weight. My parents sit exhausted, haggard, falling asleep in their chairs. In my family, we never fall apart during the hardest times. We hold, we all hold. Later is when the toll shows.

My mother is having spells where she becomes dizzy. I take her for an MRI, stand next to her while they slide her entire upper body into the coffinlike encasement. She is claustrophobic. They give her a panic button, and this semblance of control helps. She asks me to stay, and I stand beside her, my hand on her ankle. The scan shows a heart valve that is stenotic, closing up, and may need surgery.

Later I take my father to the same medical clinic for an MRI and blood tests. Dad's worried about cancer, since he had it long ago. He wants me to go into the doctor's office with him. We sit down in the cramped space side by side, and the doctor walks in past our knees. Dad takes a picture of William out of his wallet, shows it to the doctor. Dad chokes up as he starts talking, starts crying. I leave him with the doctor. He needs to talk to someone outside the family.

The war machine keeps gearing up, almost unchallenged. Or what challenges there are get little attention. There is no Paul Wellstone anymore, few voices taking on the president. Each day lumbers inevitably toward bombing and death. Dan writes from back home in British Columbia: have I heard that Jean Chrétien's communication director

called Bush a moron? It gives me a moment of hope, this lovely insult from Canada, a contrast to the cowed and sycophantic news coverage here.

Dad's tests reveal nothing, and we think it is the stress of William's death that is causing him this physical pain.

THERE IS CHRISTMAS to think about, and I won't be with them. I have to go home, rebuild my life. Before I leave, Dad asks me to take him shopping for a gift for Mum. He always leaves the gift buying to Judy, but he is thinking his own thoughts about Christmas this year. He wants to take Mum to some movies. Will I take him out in their van to find tickets? We tell Mum we're going to the hardware store, but instead we spend a glorious afternoon in subterfuge, making the rounds of old-fashioned movie theaters, buying her books of tickets. Dad isn't content to wait in the van. Instead, we park, walk through the cold and sun into the art deco lights of the old Highland and Grandview theaters. Dad pays for the tickets in cash, squinting at the dollars and thumbing them out of his old leather wallet. When we've got the tickets, we walk around the corner to a used bookstore, where deep in the basement he finds used CDs of Tennessee Ernie Ford and tapes of Christmas music. He's in hog heaven.

\mathcal{D}an picks me up in Spokane. We stay with his relatives nearby. They could not be kinder, but I can't control my emotions anymore. All I want now is to be home, to unpack my suitcases, to grapple for some routine.

Back in my own front yard, we string colored lights on an intertwined alder and yew, shaping them to look like a regulation Christmas tree. Every time we round the bend toward my house, the tree is brilliant across the field. We tour back roads and city streets, seeking the brightest and strangest Christmas lights, then declare ourselves winners of the best-decorated-tree-in-the-valley contest.

We share intimate dinners with friends we have known and loved for decades. They know Dan and me as individuals and now welcome us together. On Christmas Eve, twenty-two of us sit together at a beautifully laid table, the colors of blue glass in the goblets and plates, the red terracotta of the walls, the lights twinkling in the windows, cushion me with the gentlest love. Our friend Sabbian has carefully thought out the seating for this mix of old and new friends and relatives. She asks each of us to introduce the person to his or her right. Her husband, Bernie, introduces me, and his words of love and support are so astonishing and sweet that I can barely maintain my composure. We go all around like that, laughing, and drinking wine and sometimes crying, our ages ranging from newborn baby to the eighties, and it is like my own large family gathered in safety and love.

But it is difficult, too. To be here in Canada, in my valley, where my friends know about William's death but where it is not ingrained in the passage of every minute, of every day. In Minnesota, the story lies beneath the skin of every conversation; it is the lingua franca.

LIFE GOES ON, that insipid and wrenching cliché, that horrible and wonderful truth.

But daily reality is not the same. Around each corner an accident is waiting. I attempt to control everything. I keep track of everyone I love.

I make an inordinate number of trips to the grocery store; in the reliable bins of green peppers and oranges, the casual movement of people buying groceries, I find stability. I reassure myself with grocery lists, with cooking, as if a full larder will ward off death.

I seek order and patterns, music and laughter. We take a class in square dancing; our teacher, Bob Dean, is almost eighty years old. Each week he drives to the school where he once taught math, and our ragtag bunch of dancers comes to learn orderly movement and change from him once again.

He calls out a Ferris wheel, where we should revolve in pairs and fours and meet gracefully. But some of us turn the wrong way, or stand blankly, not knowing what to do. Sometimes we crash into each other. Gradually we improve. This fashioning of unskilled, unknown random dancers into predictable patterns, where chaos sometimes resolves into rhythm and grace, soothes and replenishes me.

We know the do-si-dos and the allemandes, where you reach out and take another dancer's hand and move forward

around the circle in time to the music. Sometimes we alle-
mande left in perfect harmony, roll away with a half-sashay,
shoot the star, slip the clutch, and swing to a wave until we
are laughing so hard the world is only this moment, this
movement.

For Christmas Day we make simple presents. We bake
shortbread for our friends. Dan goes to the fire and heat of
the forge and makes me a wrought-iron tool for my wood-
stove. I enlarge and frame photos I took of him making the
railings in the summer. I ask him to join me on a phone call
to my parents, an awkward way to be introduced, and I un-
derstand why he would rather wait for summer to meet
them in person. But I insist. There is no certainty, ever, that
any of us will live until the summer.

We talk with my mum and dad. They are charming and
charmed, and I am so happy that there is a new person, Dan,
entering our family. Mostly, I can't remember the words
now, the topics. I just remember the mingling of voices and
laughter, my father's weak voice sometimes strong and
clear, my mother's so down-to-earth or repeating words to
Dad that he didn't catch. There is my own voice, which is
full of love and yearning for Dan to know them, there is his
own, knowing what this means to me. I remember that con-
versation like the sounds of ice water rippling over glaciers
in the sun.

*I*n January, I dream about a phone call with my father. It is just him and me. He answers in a faint voice. He says, You know how I said I might not make it? It won't be long now. His voice keeps getting fainter, and I scream into the phone, DAD! DAD! But the phone has dropped.

I wake screaming, gasping and moaning. My chest is caving in, and I can barely breathe.

IN APRIL, I have the most stunning dream about William. Our family is at a big supper in a prestigious and beautiful old building in St. Paul. It is a family time, like Easter or Thanksgiving, and the room is full of families sharing this supper, each at their own tables. Light streams in from high windows, shedding a dusty golden glow over us. My entire extended family and friends sit together at a huge table. Supper is over and some of the older people prepare to leave. My sister Donna suggests we sing a song, one we barely know, a beautiful and emotional song like "Jerusalem." We don't feel up to singing, but Donna insists and passes out lyrics she has copied by hand. In the midst of this hall of people, we rise as a family and sing "Jerusalem." We sing raggedly, but Dad's voice is strong, and he carries us when we lose the thread or when we begin to cry. We finish and sit down. The hall is quiet, in that kind of polite silence that happens when no one knows quite what to do. Then, as a

few people understand what they've just witnessed, who we are and why we sang, they begin to stand, and they all stand. They raise their glasses, wineglasses fluted like tulips, each glass identical.

In my dream we look up and see the people, their glasses raised, and they toast us with the gentlest touch of glass to glass. The hall rings with the chime of crystal, the sound of one bell, and the sound rises in the room, through the golden dust motes to the light of the windows. We stand in silence and listen, watch the sound rise to the rafters. No words are said, but everyone knows this is for William. It's why we sang. It's what the people understood and why they made their tribute.

\mathcal{D}ad's pains were really cancer. On May 5 he is given one to three months to live.

There is no question of heroic treatments or miracle recoveries. Dad knows it; we all know it. There is time now only to adjust, to do our best to finish up our lives together. For Dad and me, this book is our unfinished business. I know this book will never be published in time for him to see it. And that isn't good enough: to fail him, to fail myself, in that way. Dad has to know his stories truly mattered to me, and that I saw them through.

I phone Linda Crosfield, a writer, typesetter, and bookbinder. Linda is my friend, and I feel I have the right to ask a favor of her. Can she take this manuscript and make a special edition of it in time for Father's Day, one month away?

The next morning she escorts me down to her workshop. The moment I walk in, amid all the paper in her basement, my eyes settle on one sheet. It is embedded with ferns and the golden seed heads of long grasses.

This could be the cover, couldn't it? I ask.

In the next week, she puts aside all other projects. We visit an art supply store, select handmade paper of forest green and prairie gold for the flyleaves. I bring her photos to scan of my father, the map of the Hudson Bay from his thesis, my photo of the wind-trained tree, the Burmis Tree in the Crowsnest Pass, his photo of the moose and wolves. She

creates a hardcover book, the pages round cornered, bound with linen string made by her aunt.

I CALL MY FATHER. I'm holding his book, the first part of this book, in my hands, but at first I'm not sure whether to tell him or wait to present it to him in person on Father's Day, a few weeks away.

It's just the two of us on the phone, him in Minnesota, me in B.C. There is no one else, no dog barking, no one coming to the door on his end of the line. There is no avoiding what's happening. Dad is thoughtful and sad and funny. You would never know he had Alzheimer's if this were the only conversation you had ever heard. It is his first day staying downstairs in the sunroom in a hospital bed the hospice people have provided. The dog and cat are on the bed with him. He has had one last sleep upstairs, he says, but now he is in the sunroom. The hospital bed is kind of neat. He likes operating the controls, but he's frustrated that he can't get out to do the manual labor he wants to do—a carpentry project at Donna's or re-laying the paving stones in the front yard. He neither dwells on nor avoids the subject of his death. He's not sure of the progression of the cancer but says it's out of our hands. I like how he says "our hands." As if his life and death belong to all of us, a collective life as well as an individual. He looks forward to the visits from the hospice people, looks forward to my brother Andy's visit soon and to my own on Father's Day with Dan.

He says he is happy about Dan and me. It is unusual to hear my father speak so personally about my choice of partner. I tell him I have found a solid, kind person who loves

me and whom I love. Dad says he trusts my judgment, and to hear him say this out loud, even though he has trusted in me in so many other ways, means so much to me.

There's no time for anything but truth, so I'm honest with my father. I've made some bad judgments before, Dad. You know I was with someone who was a very bad choice before. But I think this time I've found the right person and you'll really like him.

Then I pause and say: Shit, that's a setup for failure, isn't it? "You'll really like this person . . ."

And we both start laughing.

Yeah, Dad says, that's the kiss of death.

It's wonderful to hear my father's laughter, even his casual use of this phrase—the kiss of death, when death's kiss has been the backdrop to our entire conversation.

Finally he asks if I will have a book to bring him. The book of his Hudson Bay stories.

Yes, Dad, I have your book in my hands. It's beautiful. I'll bring it to you on Father's Day.

He tells me he looks forward to that, and to my arrival.

At five the next morning the phone rings. It's Judy. Dad has taken a terrible turn for the worse, was restless and up three times in the night, has fallen badly. He is conscious, but it is time for us all to come.

It is Memorial Day weekend in the States, so flights and connections are impossible. To fly from my home in the mountains would require four connections, any one of which is bound to fail. Instead, Dan drives me south to Spokane, the second trip for a death in my family since we met nine months ago, and I get on the Greyhound.

I call St. Paul several times a day from the many bus stops. The mountains and hills of Montana, the badlands of North Dakota, two sunsets, and a sunrise roll by. Once Dad gets on the phone, but he can barely speak and calls out for Mum. I arrive thirty-six hours later, at 6:30 in the morning. Judy and David meet me, take me to Mum and Dad's. They tell me Dad lost consciousness twelve hours earlier. That he kept saying over and over that we have to get to the bus depot for Rita, to the airport for Andy.

Dad is in his bed in the sunroom. He's curled up in fetal position, his sailor hat on his head. There are no tubes attached to him, no beeping machines. Just my father, his labored breathing, and the morning sun. I go sit with him, take his hands. Tell him I love him. That I'm here and Andy will be here in a few hours. I hold his hands, put his book into them. Here's your book, Dad. All your stories. There's a picture of you inside. And your picture of the wolves and the moose. A picture of a wind-trained tree. Your map of the Hudson Bay. All your stories are here, Dad, all the stories you told me.

I move his fingers across the textures of fern and grasses of the front cover. You would be so proud, Dad.

Donna comes in, and we sit with him. His breathing is ragged and he is struggling. She gives him his small dose of morphine and he eases.

An hour later his legs begin to mottle, and his feet are cold. Donna runs for Mum upstairs, where she is resting. She comes down and we stand by him, sit with him. His breathing stops and restarts. Stops again for longer and starts again.

It's okay, Ross, my mother tells him. I love you. You can go now. It's okay. You can let go.

And then, in the space of a breath, he does.

ANDY ARRIVES by plane an hour later. Brian will be here soon. There is no rush to remove our father from the house. There will be no autopsy, no embalming. We each take the time with him that we need. We call the funeral home hours later. In the sunroom, the attendants put him into a maroon corduroy bag. It is like a sleeping bag, and there is some comfort in this color, this warmth and softness. We ask them not to cover his face as they take him from the house. They wheel him through the living room, out through the front yard, where Judy and David stand together beneath the large trees. It's as if Dad is getting to say his last good-bye to this place he loved.

LATER, OUTSIDE the funeral home, we all get out of Judy's van, and in a moment of mass stupidity, watch as she locks the keys inside, with the motor running. Her stepson, Mike, arrives—grinning—with the spare key, as the young and somber attendant escorts us all into the room where she will ask the necessary questions. We know the questions; we know the answers. We know this routine too well. Judy knows the phone number of the funeral home and cemetery by heart.

The woman, who is doing her best, cautions us that her next question will seem strange: Do we understand that cremation is not a reversible process?

The six of us—Mum, Judy, David, Donna, Andy, and I—look at each other, find the same twinkle in each other's eyes, and start laughing.

Donna pulls herself together and says, Do you mean that once we decide to cremate we can't change our minds?

No, the woman says, you can change your minds right up to the point of cremation. But I have to ask if you understand that cremation itself is not reversible.

We understand, we tell her. We truly understand.

In the van, we speculate how far back people think it could be reversed. Until the person is walking again? Just add water and stir?

Andy goes down to Dad's workshop, makes a beautiful oak box for the ashes. Andy's wife, Chris, paints a fern on the box.

Brian arrives from Winnipeg, and now we are all here.

We write obituaries and plan what we'll say at the graveside. Family members bring photos, and the display boards are made. We are accomplished at this task; it's the fourth time we've done it in seven years. In an upstairs room, we find more pictures of Dad—some are on the photo boards from Mike's funeral in 1997, his son John's in 2001, and William's seven months ago.

Andy sets up a display of Dad's hand tools, chisels and awls, augers and bevels and planes.

Sometimes we gather in Judy's backyard in the spring sunshine. We sit at her big table and read the paper, joke and eat and talk. We figure out more details about what we'll say at the graveside, what we'll do later. I marvel at our strength when we are all together, look at my brothers,

love them so deeply, am so grateful that the men in my family are so strong and loving, as funny and tough and tender as the women.

Friends come by. Our relatives from Winnipeg arrive to join us.

On May 29, the day of Dad's funeral, we start our procession from a nearby park, carry Dad's ashes past the house, and then, at Oakland cemetery, where William is buried, we gather once more.

The trees are green and fresh; huge oak and elm seem to gather with us.

Judy reads Dad's favorite poem, "The Builders."

All are architects of Fate,
Working in these walls of Time:
Some with massive deeds and great,
Some with ornaments of rhyme . . .

In the elder days of Art,
Builders wrought with greatest care,
Each minute and unseen part:
For the Gods see everywhere.

Let us do our work as well,
Both the unseen and the seen;
Make the house, where Gods may dwell,
Beautiful, entire, and clean.

Mum speaks of Dad as the captain of our ship. Donna passes the oak urn to each person so we can touch it and say our

good-bye. We sing a ragged version of "The Old Rugged Cross."

Then we bury our father's ashes three graves over from William's.

We go back to Judy's, to the displays of photos and hand tools, Dad's academic awards, his thesis, and his book of stories.

Judy calls us to the staircase, where Andy asks people to speak. Family and friends and neighbors pay their tributes. A great-granddaughter plays "Auld Lang Syne" on her violin.

And then we tuck into a feast of all Dad's favorite foods. Baked beans in honor of his Presbyterian background, roast beef and roast pork, sliced tomatoes and potato salad, cole slaw, apple pie with sharp cheddar, and bowls of peanuts and butterscotch candies, the kind he liked to filch from the Cub Foods bulk bins.

MONTHS LATER, back home in B.C. I pick up one of Dad's plant books, look up the Latin term for fern. *Pteridium aquilinum*. I stand staring at his books, his old sheaves of paper, his lists of topics from the tapes he made me, the yellowed photos in his thesis.

Dad was the glacier receding, William the swift river. We are the beaches left behind. It is our job to weather, rebuild, and regrow.

\mathcal{D}onna calls to see how I'm doing. I tell her I'm okay. Writing. Spending a lot of time with Dan. We go for long walks. We're making firewood together. I can feel Dad when I am out in the forest or when the wind is strong and cold.

Donna talks about the time when Dad first got lost in the woods. Woods he knew like the back of his hand. Woods he logged and groomed, on paths he made and named. She said that day, when her husband found him, Dad was shaking and scared and crying.

We all walked those paths with our father or drove along them with him in his battered truck, tightening our shoulders as he made the hair-raising turns.

Even if what we really wanted at that moment was to go back into the house or go swimming or sit and read a book, he always wanted so badly to show us his work, for us to love the woods as he did, the paths he'd cleared and named after the trees.

He told us their names in Latin. *Tilia americana,* basswood; *Quercus alba,* white oak; *Populus tremuloides,* quaking aspen; *Ostrya virginiana,* ironwood; *Picea glauca* and *Picea mariana,* white spruce and black.

He showed us, among the trees, where the deer walked.

In my turn, I have made those same paths in my own back yard. Am learning the names of the trees: *Pinus monticola,*

western white pine; *Larix occidentalis,* Western larch. I know the paths and where the deer bed down in winter.

There are days now when I walk in my woods. And there are other days when there is nowhere to be with my grief. All the forest paths are too deep with rotten snow. All roads lead only up the valley or down. There are no byways open for my heartbreak to spill into.

My heart breaks over and over. For William, entering his first big adventures. For my father, his life closing down until one day, small and frail and humiliated, he was lost just steps from the cabin.

On his tapes, in his stories, he taught me the world, challenged me to take it on.

DAD'S STORIES won't change now. They are always journeys, unexpected bounty, confidence in stormy waters, practicalities, and lists. They are a fixed point for me to anchor to, to keep me afloat.

My father described a shallow lake, colored a deep yellow brown by the glacial clay, and how the action of the wind kept this fine clay suspended in the water.

It was a striking sight from the air, he said, when a stream of clear brown muskeg water entered the yellow brown of the lake. The stream maintained its identity for a long way into the main body of water.

These deaths in our family are streams entering large water. Each one needs his story told until he is ready to settle.

EPILOGUE

And so, young lady, what have you done today to justify your existence?

I've written this poem to you, Dad. I've done it. It has taken me years, but I've done it.

Yes, you did.

You got one more story for me, Dad?

Sure, maybe this will help.

ONCE AFTER THREE WEEKS, *we came into a small Hudson Bay post. It caused some excitement, our canoe coming across late in the evening, as they didn't see that many people traveling those waters. By the time we got there, why a good bit of the Indian community and the Hudson Bay people were down. It was just pleasant to visit around.*

I can see Dad there, in the jacket he always wore. Brown and yellow checks, heavy wool for cold nights. His hair and beard are dark and full. His eyes always strong and clear. I can see him stepping from the canoe, always ready for a good long talk, always ready to meet people. As they visit, they all watch one child.

There was a crow on a post. There was a line of posts, every twenty feet or so. This little kid—maybe four or five—was trying to catch the crow. He'd chase the crow from post to post. It was such a cute and innocent game. He'd grab for the crow and it would hop to the next post, and then he seemed to sense victory

as the crow was on the last post and he leapt for it, feeling that
the crow had nowhere else to go.

The crow flew off, the kid stood there in wonderment, and
the next thing he said was: "Jesus Christ, watch that little bas-
tard go!"

All of them, the botanists, the Indian community, and
the Hudson Bay people, start laughing and make their way
to their evening quarters.

Dad?

We got to the end, Dad, didn't we?

FRED ROSENBERG

\mathcal{R}ita Moir is the author of *Survival Gear* and *Buffalo Jump: A Woman's Travels,* which won the 2000 Hubert Evans Non-Fiction Prize and the 2000 VanCity Book Prize. Her essay "Leave Taking" won an *Event* creative non-fiction award in 1989 and has appeared in numerous anthologies. Moir has also written for CBC Radio, the *Globe and Mail,* and the *Toronto Star.* She lives in Vallican, British Columbia.